Samuel French Acting Edition

Detroit '67

by Dominique Morisseau

‖SAMUEL FRENCH‖

ISBN 978-0-573-xxxxx-x

www.concordtheatricals.com
www.concordtheatricals.co.uk

DETROIT '67 was first produced by Public Lab at The Public Theatre in New York City on February 26, 2013. The performance was directed by Kwame Kwei-Armah, with sets by Neil Patel, costumes by Emilio Esosa, lighting by Colin Young, and sound by Shane Rettiq. The cast was as follows:

CHELLE. Michelle Wilson

LANK. Francois Battiste

BUNNY . De'Adre Aziza

SLY . Brandon J. Dirden

CAROLINE . Samantha Soule

CHARACTERS

CHELLE (MICHELLE) – Black woman, late 30s, strong, steadfast, firm, and not easily impressed. A widow, mother, and sister. A loving heart beneath her pride.

LANK (LANGSTON) – Black man, early 30s, cool, loving, and charismatic. A dreamer. Has a special effect on women – but not a womanizer. Chelle's younger brother.

BUNNY (BONITA) – Black woman, mid-to-late 30s, fun, spunky, sexy, and joyful. A friend and sometimes a lover…Never lets nothin' get her down.

SLY (SYLVESTER) – Black man, late 30s, hip, slick, and sweet-talking. An honest hustler and numbers man. Fiercely loyal. Lank's best buddy.

CAROLINE – White woman, late 20s/early 30s, beautiful, quiet strength, troubled, soft, and mysterious. There is a world of danger behind her eyes.

SETTING

Detroit, Michigan

TIME

July 1967

ACT I

Scene One

(Lights up on the basement of a two-story home. It is an unfinished basement, but efforts have been made to make it look inviting. A little balcony with stairs spills from upstage right. A board, some cabinets and a couple of stools makeshift a bar.)

(Pictures of Motown artists adorn the walls. Proud posters of Joe Louis and Muhammad Ali. Somewhere else – a photo of Malcolm X. Big tack through Malcolm's forehead.)

(A big old freezer leans against the upstage left wall. Somewhere – a washer and dryer and sink. A few clothes hang on a line.)

(A string of Christmas lights lies on an old shabby couch, which sits in the middle of the floor. Next to it, an old recliner. Crates covered by cloth make a coffee table. A couple of pipe poles stand as pillars on both sides of the space. Height markings are somewhere on the wall. A name in cursive. A drawing of a huge four-pointed star. A huge black fist. A very bad and lumpy portrait of a brown girl.)

(Behind the couch against the wall is an old record player. It plays the Temptations **"AIN'T TOO PROUD TO BEG"**.*)*

*(**CHELLE** sings along as she works to untangle the Christmas lights. Suddenly the record skips.)*

CHELLE. Dang it!

(She hurries to the record player and moves the needle past the skip. Goes back to singing. It skips again.)

CHELLE. *(cont.)* Not this part…come on!

(She goes to fix it again.)

(to the record player) You gonna behave now?

(Waits. Watches it. It seems cool. She goes back to untangling the lights. The record player skips again.)

Dang it! (She plays with the needle.) You got something against David Ruffin? Hunh? What's the matter? (She waits for an answer from the player.) Ohh…you wanted to see him in concert? Honey, me too. I was mad he didn't show up. He can sing you outta your drawls, you let 'im. But that's no reason to mess David all up right now. He ain't a bad man. Just a little troubled, maybe. But troubled don't make you bad. Can't nobody sang like him… Hell, can't nobody sang like none of the Temptations. They all got voices of honey you ask me. So don't go scratchin' up on David just cuz you mad. You let David play.

(She puts the needle back on the record. It behaves.)

That's better. Got us a party happenin' this weekend, and I need you to act right. Alright now?

(Somehow, the player agrees. Be imaginative.)

(CHELLE continues untangling the lights. It's creating much displeasure.)

CHELLE. Lawd…come on thangs! *(She tangles them more.)* Dang it!

(A colorful knock at the top of the stairs.)

BUNNY. *(offstage)* Hey hey hey! You want some comp-naay?

CHELLE. I'm down here Bunny! Come on in…

(A firecracker of a woman, BUNNY, comes on down the steps. It is an art for her. She wears a one-piece jumpsuit, bangles everywhere, and the highest of high-heeled shoes.

Face fully beat with fake lashes n' all. Middle of the day? No matter.)

BUNNY. What's happenin' mama? Heard y'all was fixin' up for a party this weekend. Movin' the party to ya folks' place, hunh?

CHELLE. Tryin' to.

BUNNY. Y'all been quiet for a few weeks since y'all took the party outta Lank's old crib.

CHELLE. Took us a minute to get him settled back over here, that's all. Now that Daddy done joined Mama up that stairway to heaven, we figure it make more sense for him to move back in.

BUNNY. Well the folks been askin' me where to go. I been sendin' 'em over to the Dukes – hate to say.

CHELLE. You ain't!

BUNNY. I had to, Chelle! Now you know I love you like potato salad, but folks pay me to send 'em to the happenin' places. They want an after-hours joint, I gotta send 'em somewhere. With y'all off the scene, Dukes done tightened it up. Even got that new hi-five record player.

CHELLE. You mean hi-fi?

BUNNY. Whatever.

CHELLE. We just had to finish squarin' up this business with Mama and Daddy's money. Took a lil' minute. Them lawyers'll try to trick you out of your own inheritance, I swear.

BUNNY. I told ya'll to talk to my man Stubby. He woulda gave y'all a good price.

CHELLE. I told you I didn't want no lawyer named Stubby. Sounds short and fat and unprofessional.

BUNNY. Fine then. You go'on over to Hamtramack and get you one of them Steinbergs or them Zielinskis – or how you say it. See if they don't charge you both your arms and your legs. And probably your mama's legs too.

CHELLE. Not Mr. Furman. We got us a deal. I told him
 to work with me on these legal fees and come time
 for him to need a car, I got Sly on the job. Get him
 somethin' for a real good deal. He seem to like them
 odds. So he took care of us just fine.

BUNNY. You say so. *(beat)* You having Christmas in July?

CHELLE. Naw, girl. Help me with this string, will you? I'm
 trying to untangle this mess so we have some kinda
 decorations. Lank supposed to be out getting us some
 more bulbs for 'em, cuz half of 'em done burned out.
 Had these since we was little ones. Everytime I leave
 Lank in charge of wrapping 'em, this is what I end up
 with. Tangled mess.

 (**BUNNY** *helps* **CHELLE** *untangle the lights.*)

BUNNY. That brother of yours shoul' got his own way of
 doing things, don't he?

CHELLE. You can say that again.

BUNNY. What ya'll gonna spend your folk's money on? A
 new car? Some baad threads?

CHELLE. Julius' college tuition is all I care about. You know
 that much. Use the inheritance for that, and pay off
 this house note with the parties. That's all I need.

BUNNY. Oooo girl, if I had me any kind of inheritance, I'd
 see the world. Tellin' you, I'd be in Rome and Paris
 and all them high 'n' mighty places with my mink
 coat and my painted nails and my tea and crumpets
 – or whatever them folks be havin'. I wanna be just
 like them white gals we be seein' at the picture show.
 Sittin' back on one of them satin sofas, fannin' myself
 and readin' magazines til' my man come back home
 from makin' his thousands to scoop me up and lay me
 right.

CHELLE. *(laughing)* You always lookin' for somebody to lay
 you right!

BUNNY. That's right, honey. 'Cept these niggers 'round
 here ain't bringing back no kinda thousands. Hell,
 they ain't even bringin' back no hundreds. 'Less them

fools done hit the numbers and picked up a big ol' stack from Sly, only thing they comin' to lay is they hair to the side with that conkaline!

CHELLE. You a mess!

BUNNY. That's why I got to do for myself, now. Keep my ear to the ground and tell folks where to get things. Go here for the best hairdo in the city. Go there if you need a new auto part. Go up if you want some good blow. Go down if you want some good bump. Go to the side if you want some down home cookin'. Go crooked if you wanna shoot the dice. Go left if you want the cheapest threads. Go right if you want the finest wine. And go to Twelfth Street if you wanna partaaaaaay... And if you ain't lookin' for none of that, then what the hell you doin' in Detroit?

CHELLE. You just better be tellin' folks to come on through to 1568 Clairmount from now on, cuz the Poindexter parties are back in the neighborhood!

BUNNY. Well alright. We been missin' ya'll parties.

CHELLE. These parties gon' be better than the rest. I gave Lank some money to go'on out and pick up some new .45's.

BUNNY. Ooooh...who you gon' get? I hope he pickin' up some more Temptations.

CHELLE. You know we got the Temps.

BUNNY. And some of that Marvin Gaye? Cuz I can work my best hip roll to his voice. It just go together the best. Like his voice got some kinda magnetic pull and my hips got the charge.

CHELLE. Got Marvin. And Martha and the Vandellas. And I still got the Miracles. I'm gon' put on a good one for you right now.

(**CHELLE** *rushes over to the record player and sets up her .45. The Miracles, "SHOP AROUND" plays.*)

BUNNY. I love me some of the Miracles, too. That Smokey'll make you throw ya drawls on stage. I wanna hit him smack in the face with mine, I ever get the chance.

CHELLE. You so nasty, Bunny.

BUNNY. That's why they call me Bunny, baby.

(The record suddenly skips. Deflation.)

CHELLE. Dang it!

BUNNY. Awww nawww nawww... That ain't never gonna do...

(CHELLE rushes over to fix the record.)

(A slam upstairs. Moments later, LANK enters the basement, carrying a box of goods down the stairs.)

LANK. Bring that next one down here, Sly!

SLY. *(offstage)* Behind ya in a sec! Gotta turn off the truck!

(LANK drops the boxes in the middle of the floor.)

CHELLE. You got the stuff!

(CHELLE rushes over to the box to look through the goods.)

BUNNY. Hey there, Daddy.

LANK. Miss Bonita – Bunny herself. Lay some on me, Mama.

(BUNNY plants a sultry kiss on LANK's cheek. He taps her on the bottom. CHELLE pulls out some posters. A velvet painting. A neon light that says "Open". Some pathetic party favors.)

CHELLE. Where's the bulbs for the lights?

LANK. *(vague)* They in there.

BUNNY. You gon' save me a dance this Friday, sugar?

LANK. I got my slowest one saved for you, Bunny girl.

BUNNY. I done told the folks y'all startin' things 'round midnight. That way they don't have to wait for the clubs to close if they don't want to. Ya'll can get the jump on folks.

CHELLE. *(head in box – displeased)* Yeah, 'cuz Bunny been sending folks over to the Dukes these days.

LANK. You ain't!

BUNNY. Just 'til y'all ready to come back out right.

LANK. Oh we ready, baby. We ready. You gon' see in one second.

CHELLE. *(in the box)* These all the bulbs? This itty bitty pack? This ain't enough for the whole string. And what's with this tacky lookin' neon sign? Where's this thing supposed to go?

LANK. They was…throwin' that away down at Roscoe's Liquor Store. Got a nice color to it. Thought we could use it for somethin'…

CHELLE. Color! We have plenty of color with my Christmas lights.

LANK. Awww Chelle, don't start wrinkling your forehead, now. I got plans that's gonna make our parties outta sight!

CHELLE. Where's the drink coasters I asked you to get? I don't see them in here nowhere.

(Another door slam upstairs.)

CHELLE. And tell Sylvester to Stop Slammin' My Doors!

(SLY enters the basement carrying another box.)

SLY. Hey hey there sweet Chelle. What's happenin' Bunny?

BUNNY. Hey Sly.

(CHELLE rushes over and goes through the box before SLY can finish setting it down.)

SLY. Whoa…peddle and ease there, mama.

CHELLE. I better find my coasters in here.

LANK. You gon' find somethin' better than them coasters.

SLY. That's right, alright…

(SLY looks at LANK inquisitively. LANK shakes his head "no". CHELLE pulls out an 8-track cassette. She looks at it strangely.)

CHELLE. What the hell is this?

BUNNY. Oooo, I seen one of them before. They got 'em down at Lucky's.

CHELLE. Where're my .45's? You supposed to be gettin' that lil' Stevie Wonder. That Junior Walker everybody talkin' about. The Elgins. The Four Tops.

LANK. I told you not to sweat it, sis. I got it taken care of. Come on Sly. Let's bring it down.

SLY. You got it man.

(SLY *and* LANK *head up the basement stairs.*)

CHELLE. Bring what down? You better be bringin' down my .45's. I gave enough money for all the songs on my list.

BUNNY. Somethin' tells me they ain't givin' two shits 'bout your list.

(*At the top of the stairs behind the door,* SLY *and* LANK *begin manuvering with something.*)

LANK. (*offstage*) Pick it up with that hand.

SLY. (*offstage*) Nah nah nah... I need to hold this part with that hand. You grab this part.

LANK. (*offstage*) Naw man! That don't make sense. I need to hold this part right here.

SLY. (*offstage*) Cool man, I got it. Just grab that one.

LANK. (*offstage*) I got it. Just don't drop that thing. Cost us a fortune.

SLY. (*offstage*) I got it, man. I got it. Just go'on...

(*Seconds later,* SLY *and* LANK *emerge onto the balcony carrying speakers and a music system.*)

CHELLE. That don't look like no .45!

LANK. This here's somethin' better than them .45's. This here's an 8-track player.

BUNNY. That's right! That's what it's called. Seen a commercial for it on TV while back.

CHELLE. Langston Hughes Poindexter! Tell me this ain't how you done spent all that money I gave you.

LANK. Now cool out for a minute, Chelle. Just listen. This here's gonna be the answer to all our problems. Tell her, Sly.

CHELLE. Naw, Sly, don't tell me.

SLY. It's true, Chelle. The 8-track player supposed to be better than a record player. You can get one in your car. You can move this thing around with you. And they say – you play some of that Smokey on this thing – his voice sound more velvet than it do right now.

BUNNY. *(intrigued)* They say that?

SLY. That's what they say, now.

CHELLE. Hmph – don't look like much to me.

LANK. Is you crazy? Look at this thing, Chelle. Ain't it beautiful? Even light up when the song play.

CHELLE. It's ugly. And weird. Look too technical. My record player plays and you can hear the needle movin' through the song. The way it dance up against the vinyl real close…that's what I like. Not no 8-track.

LANK. Give it a chance, Chelle. I'm'a set this up with Sly and then we gonna play you somethin' on it. You'll see. It sounds much better than that ol' record player.

CHELLE. *(faint)* Daddy gave me that record player.

LANK. Won't be no scratchin' on a 8-track. Song play all the way through – smooth.

BUNNY. Now that sound like somethin' you need.

LANK. Dukes ain't got nothin' like this. We'll shut them down so quick, folks'll be like – Dukes who?

SLY. It's true, Chelle. Right now, Dukes ranked number one for after hours joints in Detroit. But you tell folks you got somethin' new to listen to that Motown on, they gonna be pushin' to get through. Believe it, woman.

CHELLE. How much it cost?

LANK. Money ain't no object when it comes to quality. Tell her, Sly.

CHELLE. Naw, Sly – don't tell me nothin'! You done spent it all, didn't you? All the shoppin' money I gave you – gone, ain't it?

LANK. You see this quality?

SLY. Top of the line quality.

BUNNY. Look like a fine quality to me.

CHELLE. Well I guess it ain't nothin' left to say since the Amen Corner done spoke. Forget my lil' record player then. I keep it to myself…

(CHELLE *moves away and goes through the boxes.* SLY *looks at* LANK *and motions for him to tell* CHELLE *something.* LANK *mouths "Not yet".* CHELLE *is oblivious.* BUNNY *notices, but merely shakes her head and says nothing.*)

BUNNY. Ya'll stand to make a killin' this month offa these parties. Folks been hittin' the after hours joints more since some of the vets done come back home from 'Nam.

LANK. Heard Otis Jones done come back home. Say he been talkin' to himself sometimes on the street.

CHELLE. Poor Otis.

SLY. That's why folks need a good place to get a drink and have a good time and leave that Vietnam blues back overseas.

CHELLE. Don't say it that way, Sylvester.

SLY. I'm just sayin' what it is.

CHELLE. Just don't say it that way. Make it sound like we doin' more than we are. We just trying to make a lil' money the way we know how.

LANK. Sly know that, Chelle.

SLY. We all know it, Chelle.

CHELLE. That's all. Not tryin' to mess these vets up more than they been already.

LANK. Ain't nobody messin' nobody up. We here to make people feel good. Make some extra money to keep my nephew in that Tuskegee Institute. I told Julius – he gonna be like one of them airmen. That's what he promised me.

SLY. A young colored brother from Detroit in school down there in Tuskegee…that's somethin' to make folk feel real good. I'll drink to that one myself – hell…

BUNNY. He gon' study all through the summer too?

CHELLE. Say he wanted to stay down there and work during the summer. *(beat)* I think it's a girl.

LANK. That's my nephew.

BUNNY. Just like his uncle.

LANK. Watch your mouth there, woman.

SLY. You, uh…you gon' be needin' some real money to keep him down there, ain't you?

CHELLE. With these parties…we should be alright. Keep Julius down there til' he graduate. My boy is gonna go all the way.

(SLY looks at LANK again. LANK finally nods and mouths "Be smooth". SLY adheres.)

SLY. Say there…uh…Lank…you know Sheplings bar on Twelfth Street gettin' sold?

LANK. *(feigning surprise)* That right? Old man sellin' it?

SLY. *(feigning casual)* Yeah, that's right. Movin' to the suburbs. Peanut said white folks all over town been tryin' to sell they property and move on out.

(BUNNY senses they're up to something and watches with amusement.)

LANK. Tryin' to get away from all these niggers movin' in, hunh?

BUNNY. Well where they goin'? Cuz if it's nice, I got news for 'em. Niggers gon' find it.

LANK. Niggers deserve nice stuff too. Hey Sly…how much he sellin' for?

SLY. Say he takin' bids. Folks that can come up with five grand can get in on the bid.

LANK. *(overly surprised)* Five grand? That's it? *(beat)* But what about the license? That's what run your well dry.

SLY. Say he gonna sell the license too. Bid on the table is 15 grand – license included.

LANK. *(overly excited)* License included?!? What's he playin' at?

SLY. Peanut say he talkin' straight.

LANK. Straight away? Fifteen grand? Whoo...that's somethin'!

(**LANK** *looks at* **CHELLE**.)

Ain't that somethin' Chelle?

CHELLE. *(nonchalantly)* I guess so...for somebody who want it. *(beat)* Not me.

LANK. Well you know, Sly...me and Chelle got that much to put in if that's what he's playin' with.

CHELLE. Oh no we don't.

LANK. Sure we do. Say Sly...we got that much from the stash Daddy left us.

SLY. Say what? Ain't that a coincidence? I was just sayin' what I was sayin' without knowin' nothin' bout that... That's funny...

(**LANK** *looks at* **CHELLE**. *She stops rummaging through things and studies him close.*)

CHELLE. What the hell's goin' on?

BUNNY. Some funny shit, fa sho...

LANK. Nothin' funny. Just thinkin' 'bout this bar Sly done brought up. That's all.

CHELLE. Sly done brought up...hunh... What you got up your sleeve?

LANK. Why you always think somethin's up my sleeve, Chelle?

CHELLE. Cuz when it come to you and Sly, it always is. *(beat)* This 8-track machine ain't just for no basement party, is it? Ya'll done bought all this stuff for some kinda scheme!

LANK. Awww, Chelle... *(beat)* Okay, loooka here... Me and Sly... We been thinkin' 'bout how it'd feel to be legit. Thinkin'...we could get us a piece of Shep's bar and start to build somethin' for ourselves. Found this stuff for a good deal – thought it'd be great for a bar!

CHELLE. So that's why you done changed all the decorations? For some bar?!

LANK. Not just some bar. A bar of our own.

CHELLE. No, Lank.

LANK. Whoa there – think about it for a sec, Chelle.

CHELLE. Nothin' to think about. I just say no.

LANK. Now hold on just a minute. It'd be somethin' to be legit. Wouldn't it, Sly?

SLY. Do better than dodgin' these pigs every second. They been cracking down on the after hours spots, y'know. Trying to catch everybody operating without a license. Get us for throwin' dice or smoking a joint – whatever they can. Dukes almost got raided couple weeks ago, but Peanut came in and told us the Big Four was round the corner. Niggers was runnin' this way and that 'fore they could shut everything down.

BUNNY. That Big Four been serious round Twelfth Street too.

SLY. When it's time to clean up the city, the ghetto be the only place they come lookin' for trash…

LANK. I'm tired a bein' treated like trash. Four pigs rollin' together to pick out niggers one by one. I can think of a whole lot more need to be cleaned up on these streets than us.

BUNNY. Wish they'd clean up them pot-holes on Grand Boulevard. Damn near flipped my car last week – whole was so wide.

SLY. They wanna clean somethin', why don't they clean up them pigs that come down here droppin' that dope off on the corner? I seen 'em talkin' to Otis a few times. I know what kinda game they playin'…

LANK. Pickin' out niggers ain't gonna do nothin' but lock away a whole lotta potential. Put us to good use, this city be full of all kinds of production. I'm tired of bein' laid off at that plant and runnin' joints outta my basement like I got somethin' to hide. Like the only way I can be somethin' is underground. I'm ready to be above ground just like them white folks. Ain't no tellin' what Detroit could be if we was all put to

good use. We could make some kinda…what's that word when things is all copesthetic and beautiful? Like perfect, damn near?

SLY. Utopia.

LANK. Utopia. Detroit could be some kinda…what's that place Malcolm went? Side by side with them other… y'know…Muhammed folks?

SLY. Mecca.

LANK. Detroit could be some kinda Mecca…that's what it could be. Colored folks moving this city forward. Get us some business of our own – make them stop treatin' us like trash to be swept away. I'm tellin' you, we get a chance to get above ground, Detroit'll be a Mecca.

BUNNY. Honey, if you can make Detroit that kinda place, I'll marry you.

LANK. You better go'on and pick out your dress then, baby.

CHELLE. And you better come on and help me finish gettin' this place ready. We need this joint jumpin' by Friday. Let them Dukes know the Poindexters are back on the spot.

BUNNY. Midnight good?

CHELLE. That's good to me.

LANK. *(to SLY – aside)* You gettin' in on that bid fa sho?

SLY. Like I told you – I'm gon' try. My number hit the other day, so I got me half. If you could pull the other half… then that'd be somethin'.

LANK. *(hushed)* Lemme talk to her.

SLY. You said it, my man.

BUNNY. See ya'll good folks later. Got to catch up with my ol' man.

LANK. Awww, don't tell me that now. You breakin' my heart baby.

BUNNY. Don't worry, honey. There's plenty of Bunny to go 'round.

*(With a luxurious twirl, **BUNNY** heads up the stairs and out of the basement.)*

SLY. I'ma go'on too. But I'll catch you at Lucky's Lank. See you soon, sweet Chelle.

CHELLE. Goodbye, Slyvester.

LANK. Later Sly.

(SLY exits up the stairs. CHELLE goes through the box. She pulls out 8-track cassettes with disapproval.)

LANK. There you go. That's that Mary Wells you been wanting.

CHELLE. *(firmly)* On .45.

LANK. You gon' like this better. Trust me.

(LANK starts to set up the 8-track player.)

LANK. Listen here, Chelle. This bid on the bar…this ain't a bad thing, y'know.

CHELLE. No, Lank.

LANK. Now just hear me out, will you? I got enough friends over here to make this spot happenin'. We won't be wall to wall up in here. Got space for more folks. Won't be competing with them Dukes no more. Our own spot – that'd be somethin'.

CHELLE. That ain't the somethin' I want, Lank. Put Mama and Daddy's hard-earned money on the line just to keep hustlin'? 'Cuz that's all a bar is. A hustle on-the-books.

LANK. That's all any kinda business is.

CHELLE. I don't wanna be hustlin' forever.

LANK. What you wanna do, Chelle? Sit on the money 'til we rot?

CHELLE. I just wanna have somewhere for Julius to return and call home. These parties are temporary. Survivin'. This house and this life is all I need. I don't wanna take on nothin' that could make us lose it.

LANK. Don't you see I'm tryin' to make things better? Invest this money so it grow into somethin' more. For you and Julius. Be the man for him that his Daddy woulda been – was he alive.

CHELLE. I know, Lank. You been a good fill-in for my Willie and I love you for it. But I don't love no bar. I don't wanna lose my son's future to no bar. Too shaky. I want him to have something solid.

LANK. Me too.

CHELLE. Then promise me you won't blow our money on this deal.

LANK. Come on, Chelle.

CHELLE. Promise me we gonna hold this house and this family together. Promise me that, Lank

LANK. Alright, Chelle. Never mind the bar.

(beat)

CHELLE. I'm gon' go up to the corner store and get us some liquor for the shelf. Where the keys?

LANK. Upstairs on the counter.

CHELLE. Be back in a few. *(beat)* I'm gon' see 'bout this Mary Wells when I get back. Bet it ain't better than my .45.

(CHELLE heads up the basement stairs. LANK, alone, goes to his 8-track player and plugs it in.)

(He picks up a cassette and smiles.)

LANK. *(to the cassette)* We'll show her, Mary...

(Mary Wells, "WHAT'S EASY FOR TWO IS SO HARD FOR ONE" plays.)

(Lights fade on LANK and his 8-track.)

Scene Two.

(Night falls on the house. The basement is dark and still. Suddenly, the door cracks open. A peek of moonlight from the balcony.)

(Shuffled footsteps come down the steps...followed by muffled voices.)

SLY. Where to? Not there – wait – to the left some – on my foot now – gotdamnit-nigger, my foot!

LANK. Over here. Right there – okay – hold on – what's that – whose foot is that? – move over more!

LANK. Put her on the couch.

*(**LANK** and **SLY** carry a large covered figure over to the couch and plop it down.)*

*(**LANK** goes over to the light and flicks on a lamp.)*

*(**SLY** stands over the unknown figure and stares.)*

SLY. She's still out.

LANK. Check her pulse?

SLY. Don't need to. She's breathing. I can see that much. She's breathing.

LANK. Thank God.

*(**LANK** walks over to the concealed figure and pulls back her cover. For the first time, we see **CAROLINE**, a young white woman, who lies motionless.)*

SLY. Say Lank, I'm gonna need a joint for this one.

LANK. You know Chelle don't like smoking in the house.

SLY. I think I'm'a need a pass on this one.

LANK. How 'bout a drink instead? Some gin in the cabinet.

SLY. I'm already over my limit...but...what the hell...

*(**SLY** goes to the bar and fixes himself a drink.)*

LANK. She bleeding anywhere?

SLY. Don't think so.

LANK. Gotta make sure.

(**LANK** *moves around* **CAROLINE** *carefully. He touches her lightly. She stays motionless.*)

(**SLY** *gulps his drink.*)

SLY. She knocked out cold.

LANK. You said it.

SLY. Maybe she might need some kinda ice pack or somethin' for her head. Right there in the corner. Look like some dried blood.

LANK. Yeah...yeah... I think we got that...

(**LANK** *goes over to the freezer and pulls out a box of frozen veggies. He brings it back and starts to set it on* **CAROLINE**'*s forehead.*)

SLY. Whoa – hold on there. You might wanna cover it with somethin' first. She get freezer burn or somethin'. Have a pack of vegetables stuck to her face.

LANK. Wouldn't want that...

SLY. There go a towel over there.

(**SLY** *points to the sink basin.*)

LANK. Right.

(**LANK** *rushes over to get the towel. He wraps the veggies and comes back over to* **CAROLINE**. *He sets it on her face. She flinches but doesn't awaken.*)

LANK. It's alright, miss. It's okay...

(**LANK** *lifts the box.*)

LANK. Maybe I should leave her be.

SLY. Maybe. *(beat)* What you gon' tell Chelle?

LANK. The truth. Ain't nothin' else to tell her.

SLY. The truth? Hell...I'd like to know the truth myself. Truth ain't comin' 'til that woman wake back up.

LANK. I pray to God she wake back up.

SLY. We must be two of the craziest niggers in Detroit right now – get ourselves involved in this mess.

LANK. Mess found us. What else could we do?

SLY. I go listenin' to you…that's my problem. Shoulda left her out there and kept rollin'.

LANK. You listenin' to me? I couldn't tell.

SLY. Yeah nigger, I'm listenin' to you. You the one think you some kinda Negro Messiah. Every time I turn around, you tryin' to part some seas or walk on water or some shit. How I get into it – where I fit in this mess – I don't know. How I let you make me bring this white girl back here, I don't know! I must be drunker than I thought.

LANK. Awww man, I ain't make you do nothin'. A man can't make no other man do nothin' – he a real man. You got hands and feet, ain't you? Drove the truck here, ain't you? You in this just as much as me.

SLY. How am I in this as much as you? I ain't the one grab her!

LANK. No – you the one sat there 'til somebody tell you what to do.

SLY. Tell me what to do?! I got feet and hands ain't I?

LANK. I ain't so sure.

SLY. Ain't nobody tell me what to do. *I* tell me what to do.

LANK. Well okay then, you said it.

SLY. Say what?

LANK. You did this cuz of you. Not cuz of me. Just like you said.

(beat)

SLY. Nigger don't be tryin' to slick talk me when I been drinkin'!

*(A door creak at the top of the stairs. **CHELLE** enters the balcony…sleepily.)*

CHELLE. Lank? Sly? Y'all alright down there? I heard ya'll comin' in…woke me up…

LANK. We alright Chelle. Go'on back to bed. We alright.

(**CHELLE** *catches a glance at the couch. She sees someone sprawled out over it.*)

CHELLE. Who's that…what's goin' on down there? Can't none of y'all drunk friends sleep here tonight…

LANK. It's nothin' Chelle – go'on back to bed now.

(**CHELLE** *peers more over the balcony. She comes down the steps.*)

CHELLE. Lank – I don't want none of your women over here tonight neither. We done talked about this –

(**CHELLE** *stops. Sees* **CAROLINE** *– passed out.*)

What the hell?

LANK. Chelle, relax now.

CHELLE. Relax – my ass!

SLY. Hold on a minute, Chelle.

CHELLE. Hold on – nothin'!

LANK. Gimme a chance to explain.

CHELLE. You better start explaining real good. What the hell is this white girl doin' down here? You done went stupid?

LANK. Hold on Chelle! It's not what you thinkin' –

CHELLE. Well tell me what it is then! Cuz I'm thinkin' you and Sly done lost y'all everlasting minds! Bringing this girl at this hour –

SLY. We got a reason for that, Chelle.

CHELLE. I ain't hearin' no reasons! Somebody better tell me what's what.

LANK. We found her, Chelle.

CHELLE. Found her how? Where was you lookin' for her at?

SLY. Wasn't lookin' for her. Just found her when we was leavin' Lucky's Place. Stumbling on the side of the road and lookin' real bad.

CHELLE. What make you pick her up and bring her here?!

LANK. She been hurt up. Somebody done hurt her up good.

(**CHELLE** *goes over to* **CAROLINE** *quickly. She pulls back the covers and sees even more bruises along* **CAROLINE**'s *face. Swollen eye. Dried blood by her temple. Greens and yellows staining her face.*)

CHELLE. *(gasps)* Good Lord. She look terrible.

SLY. Did a good number on her, whoever they is.

CHELLE. *(leaning to* **CAROLINE**'s *chest)* She breathing. Thank God. *(beat)* Y'all didn't...y'all ain't messed with her –

LANK. Come on, Chelle.

CHELLE. Just have to ask. *(beat)* What happened to her?

LANK. Caught a glimpse of her when we was leaving Lucky's. Stumbling 'round on Chicago Boulevard. Lookin' like she might fall right into traffic.

CHELLE. Lord...she probably done got robbed. What was she doin' on Chicago?

SLY. Thought maybe she was drunk and done forgot where she was. I seen that a few times.

LANK. Slowed down to ask if she was okay. That's when we saw her up close. Lookin' in bad way and not really all there. Mumbling somethin' to herself. Not really makin' a lot of sense. I leaned out to ask her if she needed a ride and that's when she looked at me... dead in my eye – in this way like...like she knew exactly where was she was for a second. Like she heard me for the first time. And she said "get me outta here." Real serious – like that. Dead in my eye. Then she got faint, like she was gonna drop right where she stood. I jump out to grab hold of her...helped her into the truck to drop her off somewhere, and she just pass right out. Couldn't get her back up.

SLY. So this...this nigger say –

LANK. Say to Sly, we better bring her back here. We leave her down there, whoever done this may be comin' back to finish the job.

CHELLE. Her face – sweet Jesus. It look like it's been somebody's punching bag.

LANK. Way she looked at me…dead in my eye like that… *(beat)* I dunno…just messed with me…had to do somethin'.

CHELLE. You get her some ice?

SLY. Took a pack of vegetables in the freezer.

CHELLE. She gonna need some ointment for this gash. Sly run up in the bathroom and get me some ointment out the cabinet.

SLY. Whatever you say.

(SLY wobbles upstairs.)

CHELLE. So where we gonna take her?

LANK. Ain't nowhere to take her. Just figure we let her stay here tonight. Figure the rest out when she wake up.

CHELLE. We can't keep her here.

LANK. What else you wanna do, Chelle? Leave her in a alley?

CHELLE. I ain't sayin' that, but she can't stay here!

LANK. What's it gonna hurt – one night?

CHELLE. What you think gonna happen when this white girl wake up in a house full of colored folks in the ghetto? You think she gonna be thankful and happy you saved her when she see all these gashes on her face? You think she gonna be able to distinguish one colored fool from the next?

LANK. How you know it was a colored fool?

CHELLE. I pray it wasn't. But if it was…we all in trouble. Even if it wasn't…all she got to do is say it was, and we all in trouble.

LANK. I know that, Chelle. Don't you think I know that?

CHELLE. If you know that then why is she still layin' on this couch? Let's get Sly, and go drop her down off at the hospital.

LANK. They takin' names down at the hospital. 'Less we just dump her at the door and keep rollin', they gonna have our names. See our faces. They wanna pin somethin' on two colored men, they just got the names and faces.

CHELLE. Then drop her off and let's keep rollin'.

LANK. Chelle! I ain't gonna do that, now. Have some kinda heart.

CHELLE. I got a heart! I got a mind and a gut too. And they all throwin' up caution signs every which-a-way.

LANK. I say she can stay here through the night, Chelle. We can do that much.

(SLY re-enters with the ointment.)

SLY. Found some ointment. Some bandages and tape too.

(He hands them to CHELLE. She begins applying it to CAROLINE and bandaging her up.)

SLY. So where we gonna take her?

LANK. She stayin' here for the night.

SLY. That right?

CHELLE. That's what Lank say.

LANK. She stay 'til the morning, and we help her get on her way.

SLY. That's what you say, then that's what it is.

(SLY heads to the stairs.)

SLY. I'm'a go'on home then. Catch you when the sun come up…

(SLY stumbles on the stairs. LANK hurries over and helps him.)

LANK. Gimme them keys, man. I got the wheels.

(CHELLE continues to bandage CAROLINE…carefully. Meticulously.)

LANK. Be right back, Chelle. You got this?

CHELLE. I guess I do, don't I?

(**LANK** *helps* **SLY** *up the stairs. They disappear behind the door.*)

(**CHELLE** *finishes bandaging* **CAROLINE**. *She stands and studies her quietly for a moment.*)

(*She grabs a pillow and props* **CAROLINE**'s *feet up. Then she covers her back up, heads to the stairs… Looks back with reluctance…*)

(*Shaking her head, she goes up the stairs.*)

CHELLE. *(softly aloud)* Good Lord, don't let it be no niggers…

(*She hits the light and disappears behind the door.*)

Scene Three

(Daylight. Sun spills through the small windows. **CAROLINE** *lies sleeping on the couch.)*

(She turns once. Then again. Then violently. Finally, she jerks out of her sleep.)

(beat)

*(***CAROLINE*** *looks around at her surroundings. Slowly, she rises from the couch. Surveys the basement. Past the walls. Sees the pics of Motown artists. Muhammad Ali. Joe Louis. Malcolm X. The four-pointed star on the wall. A black fist. The self-portrait of the lumpy looking brown girl.)*

(She freezes. Slightly bewildered. Slightly intrigued.)

(She passes a mirror on the wall. Looks at her reflection and gasps!)

(She studies herself in horror. Lifts her bandages. Her bruised eye. Her swollen jaw. She touches her face gently…pressing at the pain and wincing.)

(The door at the top of the stairs opens and **LANK** *emerges.* **CAROLINE** *halts.)*

LANK. Hey there, Miss. I guess you're up now, hunh?

CAROLINE. Who are you?

LANK. I'm Lank. Brought you some breakfast. My sister made it, not me. Some eggs and toast. She can burn… my sister can…

CAROLINE. Lank?

LANK. That's right. This is our house. Me and my buddy Sly…we picked you up last night…standing out there off Chicago Boulevard…

CAROLINE. *(sobering)* Oh. Fuck. Right.

*(***LANK*** *sets down the tray.)*

LANK. We didn't do nothin'...just found you stumblin' 'round and brought you back 'cuz...you was hurtin'. You was needin' some help, remember?

CAROLINE. Yeah... Yeah, thanks, um...shit.

LANK. I can call somebody for you. Call you a cab or drop you somewhere. If you just tell me where I can take you...

CAROLINE. No! – Uh, thanks but...no...thanks. *(shift)* Where am I?

LANK. You over here on the west side. Twelfth Street and Clairmount. You ever been over these parts before?

CAROLINE. Twelfth Street. Sometimes. *(quickly fixing)* Not really though. Not much. But yeah – no.

(He offers the toast again.)

LANK. Some food. That's what you need. Somethin' on your stomach.

(CAROLINE looks at the food. At LANK.)

LANK. Go on.

(CAROLINE politely pinches a piece of toast and nibbles.)

CAROLINE. Good jam.

LANK. My sister makes it from scratch. Jars it.

CAROLINE. She's good.

LANK. She knows it too.

(CAROLINE laughs faintly.)

She ran out to the bank. She'll be back in a few. Maybe she can get you some of her clothes to put on. Help you get cleaned up some. You got some family? Somebody I can call for you?

(CAROLINE stops nibbling.)

CAROLINE. No, I'm alright. That's okay. *(shift)* I should... um...I should give you something for your help and everything... *(She looks around herself.)* I'm just gonna get my um...my purse?

LANK. Purse?

CAROLINE. It's gone? My purse.

LANK. I didn't see you with no purse, ma'am. Sorry.

CAROLINE. *(panic)* Shit! Motherfucker!

LANK. Whoa – Miss...if it's some money you need – some fare or somethin', my sister and me – we can help with that.

CAROLINE. Yeah?

LANK. Yeah, if you needin' somethin'...

CAROLINE. Yeah... *(then quickly)* No, uh...Mr...

LANK. Lank, remember. Name's Langston...but folks 'round here call me Lank.

CAROLINE. Riiight Langston. Yeah, okay, um...thank you for the food and for your help.

LANK. You gonna be okay?

CAROLINE. The bathroom. I need the bathroom.

LANK. 'Course. There's one in that washroom right there. Got some towels in there too, you need one.

CAROLINE. Great, thanks.

(CAROLINE exits. LANK watches after her for a moment.)

(The door to the basement opens. CHELLE comes down the stairs.)

CHELLE. She woke up yet?

LANK. In the next room washin' up.

CHELLE. She tell you anything? Who she is? What done happened?

LANK. Ain't said much yet. Just gettin' her bearings. Don't think she has nobody, Chelle.

CHELLE. What you mean? She didn't give you no people to call?

LANK. Say ain't nobody to call. I think she in trouble.

CHELLE. Oh Lord...that mean we in trouble with her. You ain't get her to tell you nothin'?

LANK. She worried about somethin'. Ain't sure what. Or who. But that trouble from last night ain't over. That's all I know.

CHELLE. I don't want that trouble followin' her here, Lank. We gotta find out who her people are and get her back to them. That's what we gotta do.

(CAROLINE *re-enters looking mildly cleaned up. Her face is cleaner. Her hair a bit tidier. She stops when she sees* CHELLE.)

CAROLINE. Thank you folks for your help and the good jam…

CHELLE. No problem, miss. My brother Langston is gonna take you to the hospital to make sure you're okay.

CAROLINE. Oh no…that – thank you – that won't be necessary…

CHELLE. Well where can we take you, honey? You got a sister or some friends somewhere? Somebody wondering where you are?

CAROLINE. No I…I'll just…I'll be fine…

CHELLE. You sure, miss?

CAROLINE. *(no)* Of course…I just…I'll just be out of your hair now… But thank you again for all your trouble…

(CAROLINE *walks over to the stairs. Then stops suddenly.*)

Say listen, you wouldn't have – or know where – I could rent a room…work for my board…for a few days or so?

(LANK *and* CHELLE *look at each other.*)

LANK. You need some room and board?

CAROLINE. Just…I don't have anything…my purse is gone, you know…

CHELLE. We could pull together a few bucks for you, miss –

LANK. I told her that –

CAROLINE. I just need somewhere to room for a week or so…just until I can leave. Pay for train fare –

CHELLE. There's Algiers Motel not far –

LANK. Won't let you stay on credit.

CAROLINE. I won't be trouble. I'd work for it. Doesn't matter where. As long as it's safe.

LANK. You can stay here, miss –

CHELLE. Lank –

LANK. If you need to.

CAROLINE. I would work –

CHELLE. We don't have no work –

LANK. We got us a bar needin' some upkeep. Doing some renovations around here. Maybe you could help with that –

CHELLE. And what we gonna pay her?

LANK. Tips.

CAROLINE. I know how to work a bar. I could do that.

CHELLE. Work for us?

LANK. Why not? My sister been needing some hands on that bar. But just so you clear, miss – it ain't during regular hours.

CHELLE. Lank!

CAROLINE. Oh that's alright with me. I'm used to a lot of irregular.

LANK. Good then. It's a deal. You help us out…you stay right here on this couch. Folds out into a bed if you like. You stay here 'til you got enough to pay for that train fare.

CHELLE. A week. That's all it take. No longer.

CAROLINE. A week – yes. That's great. That'll do.

(*Beat.* CHELLE *silently fumes.* LANK *extends his hand to* CAROLINE.)

LANK. Welcome to the Poindexter house, Miss…Miss?

CAROLINE. Caroline.

LANK. Caroline. Welcome. We good people here. Hard workin', hustlin' people. You gonna be just fine. That's my sister, Michelle.

(CAROLINE *nods.* CHELLE *remains stern.*)

LANK. *(cont.)* She's gonna take you upstairs – get you some clean clothes to put on.

CAROLINE. You don't have to –

LANK. It's fine. Ain't that fine, Chelle?

CHELLE. Oh yeah, it's fine alright. *(beat)* Go'on up them stairs. To the right, down the hall. I'm right behind you. Gonna pull some laundry for you.

(CAROLINE moves up the stairs.)

CAROLINE. Thank you both. Really. You're good folks.

(CAROLINE slowly disappears behind the door.)

CHELLE. You done went plain stupid.

LANK. What I tell you? She in trouble, Chelle.

CHELLE. You damn right she in trouble! Can't figure out whether she comin' or goin'. Lookin' like a wild animal that done went astray.

LANK. You ain't see her like I seen her. Standin' on the side of that road – lookin' me in my eye like the devil himself come to claim her. I just can't send her back out there just yet. Can't have that on my soul... She just need a little help, is all. A little help and a little time.

CHELLE. A week, Lank. And her time run out. You hear me?

LANK. A week, Chelle.

CHELLE. And this one Lank...she ain't for touch. You understand?

LANK. Come on now, Chelle. That's not what this is about. I'm just being friendly. That's all.

CHELLE. I know you, boy. I know your kinda friendly. And I say – keep your friendliness to yourself...or this gonna be a short week.

LANK. Go'on help her get into somethin' clean, Chelle. Help her out, will you?

(CHELLE eyes LANK firmly. Then she turns, grabs some clothes from the line, and heads up the stairs.)

CHELLE. *(muttering)* Done invited a white girl to the joint...
 tonight's gonna be some kinda party...

(The door closes.)

*(**LANK** remains...contemplative for a moment. He looks
at the tray of half-eaten food. He lifts it, and carries it
up the stairs.)*

(lights fade...)

Scene Four

(*"DANCING IN THE STREET"* by *Martha and the Vandellas plays.*)

(*Lights up on the basement – in full pre-party mode.* **CHELLE** *moves quickly about the space, filling bowls of nuts and setting out napkins.* **LANK** *stacks up songs by the 8-track player – which lights up as the song plays.*)

(**BUNNY** *sits on a stool and rocks to the music.*)

BUNNY. This is my jam! Oooo Lank, baby – this 8-track player is sounding real good!

LANK. Didn't I tell you, woman?

(**CHELLE** *looks at an empty bowl.*)

CHELLE. Who ate the nuts that quick?

(**BUNNY** *points at* **LANK** *as he devours a batch of nuts in his hand.*)

CHELLE. Lank! That ain't for you! You eatin' 'em all up before the guests even get here.

LANK. What? I'm testin' 'em out!

CHELLE. (*yelling*) Caroline! We gonna need some more of those cashews! And you finish mixing that punch?

CAROLINE. (*offstage*) Almost!

BUNNY. This some shit I just can't believe.

CHELLE. Don't even mention it, Bunny.

BUNNY. Y'all got a white girl over here in the ghetto runnin' 'round under y'all like some kinda maid? This some shit'll make ya mama and daddy raise right back out they graves. Everybody gonna wanna see some of this.

LANK. Not a maid, Bunny. She's just helpin' us out. That's all.

BUNNY. What you know about her? Who's her people?

CHELLE. Ain't said. She been keepin' real quiet and polite all day. Too polite.

LANK. She still a little shook up, that's all. Just trying to get on her feet.

BUNNY. Well whatever she doin' – it's enough to have this place packed tonight. Word done got out quick. Folks can't wait to get served by a white girl over here! White girls can get the joint jumpin' every time. You even mention some kinda blue eyes and niggers will stop what they doin' to get close enough to have a gaze. Swear it – white girl is a natural aphrodisiac.

CHELLE. Hush, Bunny.

BUNNY. You'll see what I mean.

*(The basement door opens. **SLY** enters with a bag of liquor. He is dressed to the nines – party suit and all.)*

SLY. Heard there was a happenin' party this way tonight!

*(**LANK** peers inside of **SLY**'s bag.)*

LANK. You brought some sip? What's the word?

SLY. Thunderbird.

LANK. What's the price?

SLY. Thirty twice.

LANK. My maaan…

*(**LANK** slides sixty cents to **SLY**.)*

BUNNY. Look at you, Sly… You done bought some new threads.

SLY. Told y'all my number hit.

BUNNY. How you the numbers man and your number hit? What kinda gamblin' rig is that? That sound like some jive if I ever heard it.

SLY. I don't cheat, now. Just 'cuz I run around collectin' bids don't mean I can't bid too. I ain't no psychic. Can't tell which number'll hit. Everybody know I'm true – black not blue. I came lookin' my best for you tonight, Chelle.

CHELLE. Go'on somewhere, Sly.

SLY. Don't be mean, woman. I came all past the pigs flashin' their lights in my face just to be up in your fine fine place.

BUNNY. They came messin' with you?

SLY. Stopped me over there on La Salle. Askin' my plans for the night. Like I need some kinda pass to walk the streets that say – No Mr. Pig, I ain't goin' to get high or drunk without makin' sho the fine city of Detroit get to tax it for they profit.

LANK. They follow you?

SLY. Told 'em I was on my way home from Lucky's. Soon as they fixed to get in my face, radio went off. Heard somethin' bout a tussle near the freeway and they took off. But not before they told me to make sure my nigger ass went home and didn't come back out.

CHELLE. Listen to how they talk.

BUNNY. Boys in blue.

SLY. Talkin' ain't the half of it. 'Specially 'round this way. Sniffin' out these joints and bustin' nigger ass like it give 'em a special kinda high. Like it's recreation, damn near.

BUNNY. Tried to grab me up last night leavin' my ol' man's. Say women like me up to no good. I know what they meanin'. But honey, if I was a streetwalker it wouldn't be over here on no La Salle. Pig wouldn't be able to afford my kinda price.

CHELLE. You ain't sass him, did you?

BUNNY. Honey, naw. Way they been swingin' them clubs lately...ain't no kinda chivalry in them ass whoopins. Men. Women. Don't seem to matter.

LANK. Well I ain't standin' round waitin' to get my ass busted. I tell you that much. Ain't so long you can hit folks 'fore they start to hit back.

CHELLE. Hush that kinda talk, Lank. We just got to make sure folks keep a low profile coming over here and mind themselves. Don't want none of y'all getting in no trouble on account of us trying to have a good time.

SLY. Don't worry. Won't be nobody else in threads this fine. That's how come they pulled my card. Said – that

brother is lookin' too happenin' in that suit. He must be trouble. Ain't that right, Chelle?

CHELLE. Move on, Sly…

LANK. Ay Sly, I got me this velvet painting I wanna hang up. Come help me with it.

CHELLE. Not that ugly thing – Lord.

*(**SLY** follows **LANK** to a corner. They create space for the painting.)*

*(**CAROLINE** enters with a bowl of punch, carefully descending down the stairs.)*

CAROLINE. High Five Punch – coming up.

CHELLE. Did you put enough Kool-Aid in it?

CAROLINE. I think so.

CHELLE. Four packs. And then you gotta drop the Silver Satin in it on a five-count.

CAROLINE. And four cups of sugar. I believe I did it right.

CHELLE. I'll taste.

(She pulls out styrofoam cups.)

BUNNY. Caroline, you ever tasted Silver Satin and Kool-Aid?

CAROLINE. No ma'am, can't say that I have.

BUNNY. Ma'am? Who you callin' "ma'am"?

CAROLINE. I'm sorry…did I say something –

CHELLE. Just called her "old". *(sips the punch)* Not bad.

BUNNY. I'm a young Bunny rabbit.

CHELLE. With a fast rabbit tail.

BUNNY. Just call me that and we be fine.

CAROLINE. Sure thing.

BUNNY. You must be from elsewhere. That must be it. *(beat)* Where you from?

*(**CHELLE** raises a brow. They watch **CAROLINE**.)*

CAROLINE. Outside of here a ways. *(quick subject change)* You know what I have had? Bali Hai. It's really something delicious.

BUNNY. Bali Hai? What you know about Bali Hai?

CAROLINE. I know that if you drink it back in three sips, it goes down smoother than oil. Tastes like you swallowed silk.

BUNNY. Umph…that's right – it does…

CAROLINE. Michelle, should I start putting the chips in the bowls?

CHELLE. Sure. They're upstairs in the kitchen.

CAROLINE. Got it.

(**CAROLINE** *drifts up the stairs.* **BUNNY** *watches her disappear. Then:*)

BUNNY. She a nigger lover.

CHELLE. Bunny! What you talkin'?

BUNNY. I'm tellin' you…she is.

CHELLE. Girl, you too much for me.

BUNNY. You hear that? Bali Hai? What's a white girl doing drinking Bali Hai? That's some ghetto smooth if I know anything 'bout liquor. She got some colored taste in her or she knows her liquor. It's one or the other, or both. I can tell you that much…

LANK. Hey – you two chicks…quit all that yakkin' over there.

SLY. Looka here looka here.

(**SLY** *and* **LANK** *hang the velvet painting up. Two black naked women lain out.* **CHELLE** *scowls.* **BUNNY** *smiles.*)

CHELLE. If that ain't tackier than my thumb, I don't know what is.

BUNNY. I think it's sexy.

LANK. Every colored brother in Detroit oughta have himself one of these hanging in his house.

SLY. Every colored brother in Detroit oughta have himself the real thing at home…ain't that right, Chelle?

CHELLE. Hush up, Sylvester.

LANK. Can't nobody look at this and not feel like dancing up on a woman – close.

SLY. You can say that again. Get you the right song? Whoooo…

LANK. I got it.

*(**LANK** goes to his 8-track player and shuffles through the cassettes.)*

SLY. All through high school – 'member them parties they was throwin' right before we was all headin' off to service? You 'member them?

LANK. Do I?

SLY. Movin' in on Marietta Wilson…just waitin' for the chance to ask her to dance.

*(**LANK** puts on the cassette. Smokey Robinson and the Miracles – "**OOOO BABY BABY**" plays.)*

SLY. I'd move in slow…pretend I was shy.

*(**SLY** demonstrates on **CHELLE**. He takes her hand. She shoos him.)*

CHELLE. Go'on now, Sylvester.

SLY. Just groove with me, baby.

*(**CHELLE** tries to fight but the song and the moves are too entrancing. They dance.)*

SLY. I remember what it would be to dance up on some mama, holdin' onto her like she was gonna go outta style if you let her go.

*(**CAROLINE** re-enters at the top of the steps with chips in her hands and looks on silently.)*

LANK. Mine was Damita Bell. She had that flip thing with her hair. I'd get nice with the DJ… Slip him a dime. That way, he let me know just when my song was 'bout to play. Then soon as the record spin – there goes my hand in hers 'fore she had time to say no.

*(**LANK** scoops **BUNNY**'s hand. She goes along without protest.)*

But I was never one of them shy brothers. I make your body feel all the layers of the tune.

BUNNY. Yeeees daddy…that's right, you do…

(**LANK** *grinds on* **BUNNY.** *Their dance is much more down 'n' dirty than* **CHELLE** *and* **SLY.**)

(**CAROLINE** *watches distantly. She enjoys the scene… and* **LANK…**)

(**CHELLE** *drifts into* **SLY***'s arms. Relaxed. Free… if only for a moment.*)

(**CAROLINE** *giggles with amusement.*)

(**CHELLE** *is brought back to reality. She pulls away from* **SLY** *– who works hard not to let go.*)

CHELLE. Go'on now, Sylvester. Lemme go.

SLY. Come on, sweet Chelle. Why you don't never let me keep you in my arms for a time?

CHELLE. Go'on now. Let go a me.

SLY. Say now, woman. I know I smell good. Don't you wanna be close to this sweet cologne I done bought with my new money?

CHELLE. I say let go. Leave me be. I got work to do.

(*Eventually,* **CHELLE** *wins. She moves toward the bar. Sylvester absorbs the rejection. Beat.*)

CHELLE. Come on down, Caroline. You got the chips?

CAROLINE. Sure… I just didn't want to disturb –

CHELLE. You wasn't disturbing nothing. Folks'll be showing up in a few. (*looks at the bowl*) Oh naw…that ain't the right bowl. We gonna need somethin' bigger than that. And some more cups. And I need to write out the prices next to stuff 'fore folks think this is some kinda charity liquor. You can help me with that too. And Bunny –

(**BUNNY** *and* **LANK** *continue to groove – unconcerned with anything else.*)

Lank! Ya'll need to finish stockin' this bar.

(*Slowly and reluctantly,* **LANK** *pulls away from* **BUNNY.**)

LANK. I'll be back to finish my dance later. You make sure don't nobody fill my card.

BUNNY. You at the top, baby.

*(**LANK** taps **BUNNY** on the bottom and heads over to the bar.)*

I'll come up there with y'all, Chelle. Tell Bunny what you need her to do...

CHELLE. Well good...in that case...you can start with the chip dip. It's gonna need some dill... And maybe show Caroline how to mix that next batch of Kool Aid...

*(**CHELLE**, **BUNNY**, and **CAROLINE** head up the stairs and disappear...)*

*(**SLY** joins **LANK** at the bar, stocking the liquor.)*

SLY. You talk to Chelle some more 'bout Sheplings Bar?

LANK. Yeah, man. I tried to convince her. She ain't movin' on the subject.

SLY. Peanut say that property could be goin' up if we don't move fast. Say them Italian mobster boys, them Greek boys, them Jewish boys...they all been lookin' to buy up some of the empty properties in the city. We don't buy this stuff up, won't be no colored folks owning nothin' over here.

LANK. They gonna hijack our idea and leave us out!

SLY. That's what I'm sayin' to you. Unrest happening everywhere. Even down at the plants, Peanut say colored men startin' to organize and let folks know they ain't takin' the short end of the stick no more. We got to do the same over here 'fore we lose everything we got.

LANK. I hear you, man. But what I'm gon' tell Chelle?

SLY. Tell her the truth...after. *(beat)* Shep be at his bar tomorrow mornin'. We can get the jump on them other boys. *(shift)* Maybe Chelle wrong this time.

(loaded beat)

LANK. In the morn. You and me. We goin' down to Sheps…
and we gonna get that bar…

SLY. My maaan…

(**SLY** *pats* **LANK** *on the back.*)

LANK. Just got to figure out how to tell Chelle…

(the sound of cars pulling up to the house…)

CHELLE. *(offstage)* Hey Lank! Turn on that music! The folks
is here!

LANK. I got it! *(to* **SLY***)* Here goes nothin'…

(**LANK** *puts on an 8-track. The music swells…*)

Scene Five

(Lights up on CHELLE. *She stands at the bar and counts out money.)*

CHELLE. *(to herself)* Ninety-seven, ninety-eight, ninety-nine...two hundred.

*(*CAROLINE *enters from the washroom, drying her hair.)*

We did good last night.

CAROLINE. Did we?

CHELLE. Sure enough. You worked this room like a little butterfly. Luring them fellas into your cocoon. Got Harold and Peanut spending more money in this place then I've ever seen.

CAROLINE. Just doin' my part...

CHELLE. You served up those drinks faster than Lank ever could. I should keep you around and send him on.

*(*CAROLINE *laughs.* CHELLE *looks at her.)*

How's that gash coming?

CAROLINE. Oh. *(beat)* It's fine.

CHELLE. Healing okay?

CAROLINE. I suppose so.

CHELLE. You ought to keep putting that ointment on it 'fore it gets worse.

CAROLINE. Oh right... Okay...

(beat)

*(*CHELLE *counts out money and hands it to* CAROLINE.*)*

CHELLE. Here you go... Twenty dollars. From the tip jar, like we agreed.

CAROLINE. Thanks.

CHELLE. I'm goin' out to run a few errands for tonight's joint. You hear Lank come in, just tell him for me.

CAROLINE. I'll let him know.

CHELLE. Don't know if it's my decorations or Lank's 8-track player or Mama and Daddy's house…or you… But one of them four is real good for business around here…

(**CHELLE** *folds her money and puts it in an envelope.*)

Be back soon…

(**CHELLE** *exits up the steps.* **CAROLINE** *looks around herself. She counts her money over again.*)

CAROLINE. Fifteen,… Twenty…

(*She moves to the clothes-line and finds a safety pin. She pins the money to the inside of her bra. It is meticulous. She's done this before.*)

(**CAROLINE** *looks around the basement, slightly bored. She heads to the 8-track player.*)

(*Filters through the cassettes. Choses Marvin Gaye. "HOW SWEET IT IS…" plays.*)

(**CAROLINE** *dances to the song with reckless abandon. She finds a pole. Goes to it. Dances with it like a lover.*)

(**LANK** *opens the door to the basement and stands at the balcony.* **CAROLINE** *dances – oblivious.* **LANK** *watches with a smile and enjoys* **CAROLINE**'s *moves.*)

(*Finally – she turns and sees him staring.*)

LANK. Hey there.

(*Beat.* **CAROLINE** *is frozen. Marvin sings on.* **LANK** *smiles.* **CAROLINE** *moves over to the player and stops the cassette as* **LANK** *approaches.*)

CAROLINE. Shit – I'm so sorry/ for bothering with –
LANK. No need for sorry/ you ain't did nothing –
CAROLINE. I shouldn't have/ been messing in your things –
LANK. It's alright. / I'm not protesting –
CAROLINE. I'm so embarrassed.
LANK. Don't need to be embarrassed. Just dancing.
CAROLINE. I had no business in your music. I was just… curious – that's all…

LANK. Curious is okay with me. I like curious. *(beat)* You like Motown?

CAROLINE. Yeah…I like it…

LANK. Yeah? Who you diggin' on?

CAROLINE. I don't know, um…all the groups you have here. Temptations. Four Tops. Gladys Knight and the Pips.

LANK. You know about Gladys Knight and the Pips?

CAROLINE. Sure. The Supremes. Martha and the Vandellas.

LANK. You diggin' on Negro music?

CAROLINE. Somethin' wrong with that?

LANK. Maybe not. *(beat)* What you dig about it?

CAROLINE. Depends on who's singing.

LANK. What about the Temptations?

CAROLINE. The Temps? Their dance moves – total synchronicity. Their harmony…their bass…it's what all music should be made of…

LANK. Mary Wells.

CAROLINE. Voice like cashmere. Real sweet sounding…

LANK. Listen at you! – Marvin Gaye?

CAROLINE. Now Marvin is something altogether different. His voice can just sort of…pull on you…

LANK. How you mean?

CAROLINE. Like…I don't know…like tug at someplace deep in you. Somewhere no one else can touch and just…moves you in a way you didn't even know you could be moved, you know?

LANK. Yeaaah…moves you real good…

(Beat. Getting a lil' hot in here.)

CAROLINE. Yep it's…good music…

(LANK approaches the fuse box. Opens it.)

LANK. Hope I'm not intruding on you…

CAROLINE. Not at all…

LANK. Just wanna check the fuse box. Almost shut the party down last night when I blew that fuse. Worse thing in the world is to be the DJ when the music stops playing before quittin' time. Folks'll be ready to chop off your neck.

(LANK *flicks switches on the fuse box. Goes to his 8-track player.*)

Think I'm gonna change that extension cord, too. 8-track player is a new breed. My sister don't get that. I try to tell her, this is changin' the way we hear music. And we got to change with it. *(beat)* You heard the difference? The cassette sound? Real smooth, wasn't it?

CAROLINE. It was. Sounded really good last night. Folks were dancing so hard, I swear I saw the walls sweating.

LANK. Yeah…now that's what a party is supposed to do. You ever dance 'til the walls sweat?

CAROLINE. Not dance…

(*Beat. Getting even hotter. Need to cool down.*)

LANK. I wouldn't have picked you for a lover of Negro music.

CAROLINE. What's wrong with Negro music?

LANK. Nothin's wrong with it. Just seem like you'd listen to those ol'classical cats. Beethoven or Chopin. Them piano dudes.

CAROLINE. What's a Beethoven?

LANK. What's a Beethoven?!

(CAROLINE *laughs and shakes her head.* LANK *looks at her.*)

Ohhh…I see… You pullin' my leg. Havin' a little fun with me…

CAROLINE. Maybe.

LANK. So you like Negro music. I like Negro music. But only one of us is a real Negro.

CAROLINE. Maybe.

LANK. Maybe?

(**CAROLINE** *laughs and shakes her head again.*)

LANK. *(cont.)* Ohh…you like to joke a lot. Like to play with me, hunh?

(**CAROLINE** *shrugs.* **LANK** *looks at her with intrigue. She returns his look. Quick beat.*)

(**LANK** *finishes at the fuse box. He moves over to the 8-track player. Changes the extension cord.*)

(**CAROLINE** *mosies across the basement floor. She brushes past the walls. The little brown girl. The four-pointed star. The black fist.*)

CAROLINE. Who's the artist?

(**LANK** *looks up.* **CAROLINE** *points to the star.*)

LANK. Artist?… You mean that thing?

CAROLINE. It's interesting.

LANK. Chelle drew that…long time ago. My ol' man – he used to have me and Chelle down here all the time. Gave us permission to write on the walls. "Mark your territory" he used to say. So…we did.

CAROLINE. She like stars?

LANK. Did she? Would make stars outta everything. Christmas lights. Dominos. Pencils. Whatever.

CAROLINE. And this?

(**CAROLINE** *points to lumpy-faced brown girl.*)

LANK. That's supposed to be Chelle. I drew it for her. Six years old. Tryin' to be thoughtful. But she started crying and told Mama I was trying to make her look ugly on purpose. She tried to make me wash it off… but Pops convinced Mama it was art, and that we'd laugh about it one day. *(beat)* Chelle still ain't laughed yet.

CAROLINE. You draw the fist too?

LANK. Nah. Pops drew that. Said it was Joe Louis' fist. Said the Brown Bomber was gonna always be a champ in this house. "That Black fist is gonna set us free." That's what my ol' man would say.

CAROLINE. You were close to your folks.

LANK. Pretty tight knit. Whole family. You?

CAROLINE. No, I...no. My folks split when I was a kid. We don't really talk much. I'm kind of a loner.

LANK. Oh...

CAROLINE. But your folks...they gave you lots, hunh?

LANK. Didn't have much, but they had this house. That's one thing they had. Both of 'em – hard workers. Mama would fry hair right upstairs in that kitchen –

CAROLINE. Fry hair?

LANK. You know...with the hot comb on the stove? *(beat/ nothing)* Anyway, Pops was an auto man. Ford Motor Company. Served 'em 'til his death half a year ago. He tried to get me in there...but that auto stuff ain't for me. I ain't never been one for a whole lotta up and down when my heart is into somethin' else.

CAROLINE. Somethin' else like what?

LANK. Doin' for myself. Finding somewhere to really be somebody and have something that no one can take from me. You know?

CAROLINE. Yeah, sure... *(beat)* But how...I mean...how do you get that, you know?

LANK. Me – I bought some property over here. Gonna open up my own business.

CAROLINE. Yeah?

LANK. That's the plan. Just hopin' it's the right one. Ain't settle in me easy yet.

CAROLINE. Maybe that's good. If it was too easy, it probably wouldn't be worth much. At least you got a plan. That's good to have. Keeps you believing in something.

LANK. What you believe in?

CAROLINE. I... *(beat)* I don't really know anymore. Things I thought I believed – changed. It's like I woke up and suddenly I'm not the same person I thought I was. I'm just in this moment and...everything before it is bullshit. *(beat)* It's good you found something for yourself. I wish.

(LANK looks at CAROLINE.)

LANK. Say – what happened to you?

CAROLINE. Oh…um…

LANK. Somebody hurt you.

CAROLINE. Langston, I –

LANK. Lank.

CAROLINE. Lank. I just…think it's best to leave that night in the past.

LANK. You sure it's gonna stay there?

(Beat. LANK approaches CAROLINE slowly.)

When I saw you out there that night… somethin' happened. I saw you look at me. Heard you without no words. You know what I mean?

CAROLINE. You heard me…

LANK. It don't make a lotta sense, I know…me bein' what I am and you – but in that moment, all the trouble could come on me ain't matter. Only thing mattered was that I felt you needin' somethin'. Couldn't pull away.

(LANK steps closer to CAROLINE. She inhales.)

CAROLINE. *(nearly breathless)* What'd you feel…

(LANK doesn't answer. Instead, he takes another step closer. They stare at each other for an extended moment …dangerously close…on the brink of a kiss…)

(The door to the basement flies opens as CHELLE enters.)

CHELLE. Hey Caroline – is there any more ice in that freez –

(CAROLINE quickly moves away from LANK.)

(CHELLE stops when she sees LANK and CAROLINE alone. The silence is revealing. CHELLE looks to LANK with instant disapproval. Her eyes bore holes through him.)

(Uncomfortable silence. Air. Tension. Thickness. Long long beat.)

(finally:)

CAROLINE. I...think we're out of ice...

> *(CHELLE's eyes remain on LANK. She makes no contact with CAROLINE as she answers.)*

CHELLE. Freezer in the garage...got plenty...

CAROLINE. Should I go out back and bring some in?

CHELLE. That'd be good...

CAROLINE. No problem...

> *(CAROLINE walks past LANK and moves toward the steps. She passes CHELLE who remains focused on LANK.)*

CAROLINE. Be right back...

> *(CAROLINE leaves.)*

> *(CHELLE glares at LANK for like an eternity. Disapproval and disgust shoot from her eyes.)*

> *(LANK feels the impulse of shame at first, and then suddenly looks back at her defiantly.)*

> *(Finally CHELLE turns and leaves.)*

> *(LANK remains still...contemplative...)*

Scene Six

(Night-time on the basement. **CAROLINE** *lies sleeping on the couch restlessly. Inaudible crowd voices outside.)*

*(***CAROLINE** *abruptly awakens out of her sleep.)*

(Beat. She sits in the silence. Restless and uneasy.)

(Suddenly the faint sound of an alarm. Police siren moments later.)

*(***CAROLINE** *listens to the sounds for a moment in stillness. As it increases in volume, she moves toward it with concern.)*

(Then quickly, **LANK** *bursts into the basement. Halts when he sees* **CAROLINE** *awake.)*

LANK. Oh – hey…

*(***LANK** *heads down the stairs carefully but deliberately. He begins to search for something.)*

CAROLINE. Hey.

LANK. Sorry to wake you. Need to grab my flashlight.

CAROLINE. It's okay – I wasn't… Everything okay?

LANK. Nah – it's a lot of trouble going on out there.

CAROLINE. What kind of trouble?

LANK. One of the joints up the street got raided. Cops went in there beatin' on folks and bustin' ass. Folks out there mad as hell and now that joint is on fire.

CAROLINE. What? Oh God…

LANK. They sayin' they 'bout to head to some of the businesses down the block and raise some more hell. *(beat)* I got to get on down there.

CAROLINE. You don't think that folks'll–

LANK. Not if I can help it.

*(***LANK** *begins to search through boxes.)*

*(***CHELLE** *enters the basement in her robe.)*

CHELLE. Lank, you hear all that noise outside? Them ain't still folks from our joint, is it?

LANK. No, Chelle. It's a bunch of trouble. Leave it be.

CHELLE. What took you so long to drop everybody home?

LANK. Dukes spot is on fire.

CHELLE. What?!?!

LANK. Couldn't hardly get the truck past for all the commotion. I got to go get Sly and get on down there.

CHELLE. Go'on down there for what?! Ain't no need for you joinin' in that business!

LANK. I ain't joinin' in, Chelle. *(shift)* Where the flashlight? I always put it in this box!

CHELLE. Lank you better stay here and don't go gettin' involved in this mess.

(**LANK** *feverishly searches through more boxes. Drawers. Shelves.*)

LANK. I'm already involved, Chelle. *(shift)* Found it. Where the batteries?

CHELLE. Lank –

LANK. *(snapping)* Chelle, where the batteries?!
(**CHELLE** *– startled – jumps to search for the batteries.* **CAROLINE** *– also frightened – jumps to help.*)

CHELLE. *(nervously)* Lank – you better tell me what's going on. Why you gotta go out there and get involved in this craziness?

(**LANK** *stops. He looks at* **CHELLE** *squarely.*)

LANK. Because I got to protect our business, Chelle. Me and Sly...we done put up the money for Sheplings.

CHELLE. You did what?!

LANK. I was gonna tell you after the deal was final. I swear I was.

(**CAROLINE** *pulls batteries from a box.*)

CAROLINE. D batteries. These work?

(**LANK** *nods and grabs the batteries.*)

CHELLE. You gave up our money?!

LANK. I had to act fast, Chelle.

CHELLE. *(stunned)* You...you just gave it up? All of it?

LANK. I did what felt right to me, Chelle. Okay?

CHELLE. No! It's not okay!!! You gave your word. You looked me in my face and gave your word! Didn't belong to you! Belonged to US!!! And you just throw it all away?!?!

LANK. I ain't throw it away, Chelle! I'ma take care of it! *(beat)* I ain't got time to stand around and feel bad about it. I got to try and convince these folks not to burn us down.

(LANK grabs a bat from a corner and heads up the basement stairs.)

Damn!

CHELLE. Lank –

LANK. Just stay here. I'ma make this right.

(LANK disappears. CHELLE is left with CAROLINE – dumbfounded.)

(blackout)

End of Act One

ACT TWO

Scene One

(Lights up on CHELLE, *hanging clothes on the line and tending to the laundry.)*

*(*BUNNY *tap taps at the basement door and peers in.)*

BUNNY. Hey Chelle – you doin' alright?

CHELLE. I'm doin'.

BUNNY. Honey, you hear about all this craziness goin' on since last night?

CHELLE. I heard.

BUNNY. Girl, Lucky's is on fire now.

CHELLE. You kiddin' me?!

BUNNY. Naw…I ain't. Folks been goin' and goin' last few hours. Ain't stopped. Folks sayin' them pigs went into the Dukes and started all kinds a hell. Beat on Buddy Johnson so bad his head damn near cracked open. Even had Martha Briggs on the floor…kickin' her in the stomach and everything.

CHELLE. Jesus.

BUNNY. Girl, the folks is so mad about these pigs…they think they fightin' back.

CHELLE. What kinda way is that to fight back? Runnin' round burnin' up the city? That ain't hurtin' nobody but us.

BUNNY. What you doin' down here with your laundry? Ain't you been outside to see what's what? Twelfth Street lookin' like some kinda smoke bomb been set off.

CHELLE. I don't wanna see. Besides, Lank said to stay put while he run to check on…this damned bar. If I don't keep busy with somethin', I might lose my mind.

BUNNY. Girl, me too. My mama and 'nem done left and went over to Toledo to stay with my Aunt Bobbie. They ain't even wanna stick around to see what's gonna come from this mess. *(beat)* Let me help you. I got to keep busy too.

(**BUNNY** *picks up the laundry and begins pinnng it to the line.*)

CHELLE. Took me three tries to get through to Julius this morning. Some of the phone lines is down.

BUNNY. You ain't worryin' him none, I hope. It's best he stay right on down there at that school.

CHELLE. He doin' real well. Say he met him a girl. She from Tennessee. She got more brains than even him, he says. Gonna bring her home for Christmas.

BUNNY. If Detroit still standin' by Christmastime…

CHELLE. I just don't wanna think about it…let's talk about somethin' else…

(**BUNNY** *looks around.*)

BUNNY. Where the white girl?

CHELLE. Upstairs in the shower.

BUNNY. Well lemme tell you…I done put out to my fishes and somethin' done bit back. I got some news 'bout your lil' hired help.

CHELLE. You done found something 'bout her? From who?

BUNNY. Stubby.

CHELLE. Aww – girl!

BUNNY. Now you know he do the books for some of them businessmen downtown that run all those nightclubs. He say a white girl who used to work over at the Red Stallion come up missin' – 'bout three/four days ago now.

CHELLE. Red Stallion? That dancin' club? One where the women be on stage in all that frimpy underwear?

BUNNY. That's what Stubby say.

CHELLE. Girl, get on. Stubby got the wrong white girl. Caroline don't hardly look like nobody's dirty dancer.

BUNNY. Ain't said she was one of the dancers. Just say she used to work over there. That's all Stubby say.

(CHELLE is momentarily quiet.)

CHELLE. What else a woman do at the Red Stallion besides dance?

BUNNY. Waitress. Work the bar and the patrons. Trust me, I know.

(CHELLE looks at BUNNY incredulously.)

Don't look at me like I got some kinda titty in the middle of my forehead. I know 'cuz I hear stuff...not 'cuz of nothin' else!

CHELLE. If she workin' at that club, she workin' around all them dirty men who go there.

BUNNY. Say she used to fool around with this big-time cop who hung there sometimes. Both white and colored men get down in there...colored men with money, anyway. Bet she be servin' up some Bali Hai. You can take a colored outta the ghetto but you can't get rid of his nigger taste. She probably make a full hundred on a good night.

CHELLE. She makin' money like that, what she need to stay here for? Stubby tell you anything else?

BUNNY. That's 'bout as much as I could get outta him 'fore the pigs showed up – nosin' around. I split.

CHELLE. They got business with Stubby?

BUNNY. Ain't sure. But I tell you this much, if that white gal come up missin', she got the law lookin' for her fa sho. Must got somethin' to hide...

(a bang at the basement door)

SLY. *(offstage)* Chelle? You home?

CHELLE. I'm down here, Sylvester!

(SLY *opens the door and enters hastily. He looks worn and disheveled. His clothes are a mess. Face sleepless.* CHELLE *and* BUNNY *gasp at the sight of him.*)

SLY. I was hopin' y'all was gonna be here.

BUNNY. Sly, what's the matter with you? You look a mess!

CHELLE. Where's Lank?

SLY. Chelle, listen here. We done got into some trouble.

CHELLE. What kinda trouble?! Where's my brother?

SLY. They took him downtown.

CHELLE. At the jailhouse?!?!

BUNNY. He got arrested?

SLY. Big Four came up on us at Sheplings. Saw us down there checkin' on the space and accused us of tryin' to loot.

BUNNY. Oh naw!

CHELLE. Did y'all show 'em your papers and prove that it was your spot?

SLY. Wasn't nothin' to show yet. Still got to get the papers changed in our name.

CHELLE. Did y'all explain that to them?

SLY. They wasn't listenin' to all of that, Chelle. They come on us shinin' flashlights in our faces tellin' us to get the hell outta there. So Lank, he got a lil' too angry. He started shinin' his flashlight right back.

CHELLE. No!

SLY. They grabbed us, Chelle. Threw us both in the car and took us downtown. Peanut came to bail us out. But they wouldn't let go a Lank. Say we gotta pay more for his bail and Peanut ain't have enough. Wouldn't give Lank his phone call or nothin'.

CHELLE. They got my brother! Lord – we gotta go get him!

BUNNY. You need some more money?

CHELLE. I got it...upstairs...I got a lil' stash.

SLY. Come on. We take my pickup.

BUNNY. I'll wait here for y'all.

CHELLE. My brother...goddamnit...not my brother!

(CHELLE *and* SLY *rush up the stairs and out.*)

BUNNY. Stay clear of that fire out there!

(BUNNY *sits alone for a moment. Unsure of what to do. She moves to the 8-track. Picks up cassettes.*)

(CAROLINE *enters the basement.*)

CAROLINE. Where's Michelle going? Is everything okay?

BUNNY. Naw...it ain't...

CAROLINE. What...did something happen?

BUNNY. *(ignoring her)* How the hell you work this player...

CAROLINE. What's going on?

BUNNY. Don't you worry. They'll be back. Just a big mess outside. Negroes mad. Po-lice mad. Even white folks mad. *(beat)* Just tell me how to play this thing 'fore I get mad too and start breakin' shit up in here...

CAROLINE. Where's Lank?

(beat)

BUNNY. He's in jail. They gone to bail him out.

(BUNNY *looks back through the 8-tracks and selects one.*)

(CAROLINE *quickly moves to the couch. She lifts the pillow and pulls out her stash.*)

(*Then she rushes back up the basement stairs.*)

BUNNY. Where you headin'?

CAROLINE. I...sorry I have to go...

BUNNY. It's a real mess out there, girl...you crazy?

CAROLINE. Sorry – I just have to go...

(BUNNY *attempts to refute, but doesn't get the chance.* CAROLINE *is already out the door.*)

(BUNNY *looks at the 8-track player with frustration. Tries to work it to no avail.*)

(The room closes in on her. She looks for a release.)

(Finally she whacks it with her hand angrily.)

BUNNY. Gotdamnit, play me some music!

*(**BUNNY** screams in frustration.)*

(lights out)

Scene Two

(*Late night in the basement. Lamp is on.* **BUNNY** *lay asleep across the couch – wildly. Legs going every whichaway.*)

(*"**MY BABY LOVES ME**" by Martha Reeves and the Vandellas plays on the 8-track player as* **BUNNY** *sleeps.*)

(**CHELLE** *enters the basement, followed by* **LANK**. *Visible bruises on his face. Greens. Blues. Yellows. Dried blood by his temples.*)

CHELLE. Come on and rest up while I put somethin' on that gash.

(**LANK** *follows quietly. He sits on a chair next to the sofa.*)

(**CHELLE** *goes to the 8-track player and turns it off.*)

LANK. What'd you do that for?

CHELLE. Too loud.

LANK. Was just fine to me...

(**CHELLE** *goes to the freezer and digs through it.*)

(**BUNNY** *moves in her sleep and slowly wakes up.*)

BUNNY. Ooo...what time is it? I passed out...

LANK. It's late.

BUNNY. Ooooh Jesus – what'd they do to you?

(**BUNNY** *takes a good look at* **LANK**.)

LANK. Sssssssshhhhh...you don't wanna know...

CHELLE. Put their goddamn hands on him. That's what they did.

(**CHELLE** *brings over a steak and places it over* **LANK**'s *eye. He flinches.*)

BUNNY. What they charge you with?

LANK. Didn't end up chargin' nothing. Said I was comin' down there to rob the place and they would hold me

'til I cracked. But when I didn't, one of 'em finally called Shep and he told 'em the truth.

BUNNY. Damn, baby, they roughed you up pretty awful…

LANK. Jefferson…the one named Jefferson, I think…he was the real bastard. Mad at me for bein' a uppity kinda nigger. Motherfucker musta had steel or iron in his boot. Shit hurt worse than any kick I ever felt.

CHELLE. I can't even listen to this no more.

LANK. Sorry, Bunny. Chelle get sensitive about it.

BUNNY. Honey, me too.

(**CHELLE** *wrings out a cloth and wipes at* **LANK**'s *temples.*)

CHELLE. These cops coulda killed you. They been known to shoot us for less. And you sittin' up here shining your light in that officer's face like it's some kinda game.

LANK. That's what you think this is, Chelle? You think it's a game to me?

CHELLE. I think you act outta impulse without thinkin' nothin' through. Just like puttin' our money into this damn bar –

LANK. Awww – I knew this was comin' –

CHELLE. Damn right it's comin'! You had no right to take that money –

LANK. Money belong to me too –

CHELLE. Mama and Daddy scraped to earn that. Broke they backs to give us somethin' to stand on, not for you to throw into some foolishness –

LANK. It's not foolishness –

CHELLE. without gettin' no papers…

LANK. Got to get the papers transferred. This is how it works over here – it ain't by the books but it's legit – better than what we got!

CHELLE. … without tellin' me the plan…you just blow it all on some ol' white man's word like some kinda fool!

LANK. I'm not a fool, damnit! I listen to you, all we ever gon' do is be quiet and safe and never have nothin' better than what we got!

CHELLE. You always tryin' to have somethin' better! But what Mama and Daddy gave us is already fine without you tryin' to change it or replace it. Ain't nothin' wrong with what we got!

LANK. Ain't said it was nothin' wrong with it! But life ain't just about keepin' what you got. It's about buildin' somethin' new. You gon' see that Chelle.

CHELLE. I'm gon' see Mama and Daddy's hard-earned money go right down the toilet cuz of your selfishness! That's what I'm gon see!

(Beat. Silent fuming. **BUNNY** *remains quiet and observant. Then finally.)*

BUNNY. Well y'all – much as I love me a good ol' family throwdown...I better get on to my ol' man. He probably think I'm layin' up with some other moe by now.

CHELLE. Where's Caroline?

BUNNY. Oh yeah...she took off.

LANK. Took off? You mean, she left?

BUNNY. Ran outta here like the devil was chasin' her.

LANK. She comin' back?

BUNNY. She ain't say. But them bus and train stations full of folks tryin' to get outta dodge. She be real lucky to hop on somethin' tonight.

CHELLE. Maybe it's for the best.

LANK. Maybe she come back.

*(***BUNNY*** walks over to* **LANK** *and touches his face tenderly.)*

BUNNY. I was real worried about you, honey. You just...you be careful for me...

(She kisses him sweetly on the forehead.)

CHELLE. Bunny, you need me to call Sly to give you a ride? They still settin' fires out there.

BUNNY. Oh naw, honey. I took the ol' man's car. That Cadillac across the street…that's me… *(smiles)* Bunny be just fine…

(BUNNY exits.)

(LANK and CHELLE are quiet. LANK moves over to the couch and stretches out for a moment. CHELLE straightens up for a moment. Then:)

CHELLE. You goin' to bed? Get you some rest.

LANK. I'm just gonna stay down here for a minute.

(a moment)

CHELLE. She may be gone, Lank.

LANK. I'm gonna stay down here. Listen to me some music.

CHELLE. What is it you seein' in her?

LANK. What's that?

CHELLE. You think I don't notice? How you lookin' at her. How you dance close to her flame. You think I don't see?

LANK. Chelle, you just bein' paranoid.

CHELLE. Ain't never see you look that way at Bunny. You toy with her like she's your play thing. But you ain't doin' that with Caroline. You treat her like somethin' to be taken serious. I don't know what you doin', but it's something more dangerous. That's all I know.

LANK. She's alright, Chelle.

CHELLE. She's a white woman, Lank. Maybe you ain't noticed, but I have.

LANK. I noticed, Chelle.

CHELLE. That's what I'm afraid of. It's like…you get around her and you get further and further away from reality. Forgettin' who you are and what this world can do to you. You come in here with your new 8-track player and your new bar and this white woman, and you think you somebody you ain't.

LANK. Why can't I just do what I do without it bein' about somethin' else? Hunh? Just for once?! *(sudden twinge)* Sssssssstttt…

(CHELLE jumps to his aid. Gently tends the wound. Beat.)

CHELLE. Gonna need some time to heal.

LANK. I know.

CHELLE. Ain't seen your face like this in a long time.

LANK. I know.

CHELLE. Not since you was like…seven or eight. You got into that fight with Patrice Cooper. You remember that?

LANK. *(laughs faintly)* Yeah. She clobbered me good.

CHELLE. I didn't care that she was littler than me. I was ready to come down there and knock that brat into the middle of next week.

LANK. You musta knocked her into the middle of next lifetime, 'cuz I don't think I ever saw her around school after that.

(They laugh for a moment.)

CHELLE. When I'd get mad at you about somethin', Daddy always reminded me that you were my little brother and it was my job to defend you to anybody who tried to mess with you.

LANK. Yeah, that's Pops.

CHELLE. It was my job to love you best. That's what he'd say. *(beat)* Lank, this is you and me. All of this. That poster of Joe Louis. That ugly picture you drew of me. That pole I used to dance with and pretend it was my boyfriend. Daddy's black fist. Those dashes on the wall where you tried to prove to me you were growing. And now, even that ugly velvet painting…

(LANK is about to object…then concedes.)

This is always gonna be you and me. We stuck together by the root. You my baby brother. You and Julius…you

the only two guys in my life that matter anymore. And I'm not gonna just sit back and let you get beat up by nobody. Not Patrice Cooper. Not the pigs. Not even yourself. *(beat)* I love you best. Just like Daddy told me to. Ain't nothin' can come along and be better than that…

(**CHELLE** *gives* **LANK** *a kiss on the forehead.*)

Don't be up too late. You need to rest…

LANK. Nite, Chelle… I be fine.

CHELLE. Nite, Lank.

(**CHELLE** *leaves the basement.*)

(**LANK** *moves to the 8-track player.* **"PEOPLE GET READY"** *by the Impressions plays.**)

(**LANK** *sits and enjoys. Basement door opens. It's* **CAROLINE.***)*

(Beat. They stare at each other for a moment.)

LANK. I thought you left.

CAROLINE. I did.

LANK. You went lookin' for me?

CAROLINE. I ummm…

LANK. *(disappointed)* Oh.

(beat)

When you leave?

CAROLINE. Tomorrow night.

LANK. What's the rush?

CAROLINE. It's just better if I leave. Would've left tonight but I… *(pause/a moment of truth)* You.

(Beat. **CAROLINE** *sees* **LANK***'s bruises.)*

CAROLINE. God…what…did the…cops do that?

LANK. Yeah…they like to play rough with my kind…

CAROLINE. Shit…

*Please see Music Use Note on page 3. If rights cannot be secured for "People Get Ready" please use a song in a similar style.

LANK. This bar I got goin'...they didn't believe I was gonna be the owner. They beat on us to keep us aimin' low. Soon as we aim high, they know Detroit gonna be a nigger city and not theirs. I'm gonna show them what's what when I got my own spot.

(*Beat.* **CAROLINE** *stares at* **LANK** *with concern.*)

CAROLINE. Lank?

LANK. Yeah?

CAROLINE. I think you should be careful.

LANK. What'd you mean?

CAROLINE. I know these kind of men...crooked law men... And they're not easy to cross. Believe me, I know.

(*Pause.* **LANK** *studies* **CAROLINE** *intently.*)

LANK. How you know?

(**CAROLINE** *is silent.*)

That night...those were cops. That's who hurt you?

CAROLINE. I was involved with one. Met him at my job. Cocktail waitressing at the Red Stallion. He was always my biggest tipper.

LANK. Why would he...

CAROLINE. I wanted him to settle down but...that was never his plan. *(beat)* Threatened to tell his wife. That's why he...

LANK. Huh.

CAROLINE. I was with him sometimes when he'd take money from folks. Criminals. On the payroll of some of the worst kind of men. Illegal businesses. There's plenty of it in Detroit...not just on this side of town. I was with him when he'd ride around in certain parts ... looking for folks to...give a hard time. One time I saw him beat this... Colored man...said he looked up to no good...beat him so bad his face looked...distorted or...something...like a monster. That's how I'd picture him in my mind sometimes. A hideous monster. *(beat)* Maybe he even deserved it. I thought that sometimes too...

LANK. Deserved it? That's what you think?

CAROLINE. No, I don't – umm... *(beat)* You tell yourself things so you don't feel...so you can go to sleep at night. Otherwise, you'd never...sleep at all...

LANK. He so low down...why'd you dig on him?

CAROLINE. I don't know what to say. I could say he took care of me. That's partly true. With money mostly. Security. But there was another part...the part that hurt but...still felt good enough. Like he was at least there...a constant...for a while anyway. And I could take the hurt that came with him much more than having nothing at all. 'Cuz having nothing...that's complete bullshit. Bullshit way to live.

(**LANK** *stares at* **CAROLINE**.)

You think I'm scum, right?

LANK. You're not those folks.

CAROLINE. How can you be so sure?

LANK. I ain't sure. I just...got a feeling...

(beat)

CAROLINE. That night I was with him...at a motel as usual. I was sick of it. We got into an argument. And he hit me...a lot. Passed out drunk. So I split...fast as I could. Pain was so bad I couldn't think. If you hadn't stopped for me...

LANK. But I did. Found you. Kept you safe.

CAROLINE. I know. I'm safer here than anywhere I've been in my whole life. *(beat)* But you're not. Not if I stay. The things I've seen...if they find even a thread between us, it'll bring you a whole new kind of trouble, Lank. I can't stay here.

LANK. Where you gonna go?

CAROLINE. Across the border. Windsor. After that, wherever the feeling takes me.

LANK. What about the feeling right here?

(beat)

CAROLINE. That night you said you felt me needing something…what was it?

LANK. Somewhere to be…

(**CAROLINE** *smiles faintly.*)

CAROLINE. Yeah… *(beat)* You know, you have this way of seeing things inside that just makes people wanna be better. *(pause)* If we both find wherever that place is to really be somebody…I hope we'll see each other there.

(*Beat.* **LANK** *studies* **CAROLINE**. *Then:*)

LANK. Say…you wanna hear a song?

CAROLINE. Yeah…

(**LANK** *goes to the 8-track player.*)

LANK. I don't want you to say nothin' much, okay? Just listen to the words.

CAROLINE. Okay…

LANK. Close your eyes.

(**CAROLINE** *does.*)

(*Gladys Knight and the Pips,* **"EVERYBODY NEEDS LOVE"** *plays.*)

(**LANK** *sits and closes his also.*)

LANK. You feel that, Caroline?

CAROLINE. Yeah… I do…

(*Lights fade on* **LANK** *and* **CAROLINE**…)

Scene Three.

(CHELLE cleans up in the basement. Sweeping, dusting corners and cobwebs.)

(Outside – the occassional sound of a tank rolling by. It continually jars CHELLE.)

("IT'S THE SAME OLD SONG" by the Four Tops plays on the record player. It skips a couple of times. CHELLE smoothly moves the needle past the skip without being jarred, and continues cleaning.)

(SLY enters the basement with a newspaper in his hands.)

SLY. Hey there, Chelle. Where Lank?

CHELLE. *(dryly)* He's not here, Sylvester.

SLY. We got us a meeting at Sheps today. Four o'clock. Furman got somebody bringing us the papers in our name. I figured I'd stop by to see if he wanted to go over there together.

CHELLE. Well he's not here.

SLY. I'll wait for him. Better I don't be hanging around out there. *(beat)* You know where he is?

CHELLE. No. *(beat)* Woke up this morning and he wasn't here. Just me cleanin' and Caroline up there fixin' a bite. No Lank.

SLY. Hope he ain't go down by Grand Boulevard. Folks is gathering to throw rocks and all kinds of stuff at them police. Mayor Cavanaugh got them big tank boys rollin' in. Say he done called in the National Guard.

CHELLE. Heard it on the radio this mornin'. Had to turn it off.

SLY. What you turn it off for? You ain't scared is you, baby?

CHELLE. You wanna talk about scared? I stepped out on the porch this morning to a cloud of smoke. Look like we in some kinda war picture. Mean-lookin' guards come down this street, hunting us like we're the enemy.

SLY. Don't you be scared, Chelle. It's gonna get cleaned up soon. President Johnson himself gettin' involved. Say so right here in the paper.

(SLY holds out the newspaper to CHELLE.)

"Govenor Romney today asked for 5,000 Regular Army Troops to reinforce 7,000 National Guardsmen and 2,000 policemen in quelling Detroit's race riot." See there? These pigs can't control us good enough. Gotta bring in the Army for some order.

CHELLE. Race riot? That's what they sayin' this is?

SLY. That's what they say so. Makin' like we just hate honkies and burnin' shit up. But I wish they'd come askin' me some questions. I tell 'em – if this is about niggers hatin' honkies, then you tell me why white folks down there gettin' they lootin' in too. Naw... this is about pigs hatin' niggers. That's what this fire is about. *(beat)* Be glad when we get this bar though. Soon as this stuff clears, it'll be good to start over.

CHELLE. Start over... *(hmph)* ...that's what you call it.

(CHELLE moves away from SLY and continues cleaning.)

SLY. Why you bein' so mean to me today, Chelle?

CHELLE. I'm busy, Sylvester.

SLY. I know why you bein' mean. You mad about me and Lank and this bar.

CHELLE. Well if you know everything, then what you askin' me questions for...

SLY. Come on, sweet Chelle. Don't be such a bitter candy.

CHELLE. Don't call me sweet Chelle.

SLY. I always call you sweet Chelle.

CHELLE. And I always hate it.

(Beat. SLY is hurt. Tries to recover.)

SLY. It was partly me, I'll admit. I wanted him to join me on this thing. Me and Lank, we like brothers, y'know.

CHELLE. He's my brother.

SLY. I just…I just know we both tired of all this hustlin'.
Dough that comes fast one day and don't come at
all the next. Got you dressed nice enough to smile at
some fine woman this day, and dressed like a wino on
Woodward the next. We just tired of the up and down.
Of not havin' nothin' we can really put our hands on.
Put our time into. That ain't a bad thing to want, is it
now?

CHELLE. What if it get burned to the ground by these fools
out here? Y'all even been thinkin' 'bout that? You sign
this deal and then you lose everything. What about
that, hunh?

SLY. We been thinking 'bout it Chelle. We done put up
signs say Soul Brother in the window.

CHELLE. So did Teddy Rollins and they still burned him
down.

SLY. Teddy ain't us. Folks 'round here know us. They know
what we tryin' to do. I done got a lotta folks over here
some of they best stuff. Helped 'em find cheap cars.
Take their numbers and give 'em a chance to have
some extra money in their pocket that ain't gonna get
taken by Uncle Sam. We good to our folks, and that
counts, Chelle. But even if it burn to the ground…we
still did somethin'. We tried.

CHELLE. You and Lank…y'all both go dreamin' with your
noses wide open. So wide I could run one of them
tanks outside right through your nostrils.

SLY. You know your problem, woman?

CHELLE. I'm sure you gonna tell me.

SLY. You don't never let nobody hold you long enough to
believe in nothin'.

CHELLE. Move on, Sylvester.

SLY. Naw Chelle, I mean it. See…you so worried about
gettin' to tomorrow, you don't never conceive of the
days and weeks and months after. Tomorrow's alright.
Keeps you livin'. But if you look far enough ahead, you
start to see tomorrow ain't all there is. It's plenty of

days after that. And when you got somebody close to you...somebody to hold onto and slow dance with... you wanna believe in everything. You wanna believe stuff can happen that'll make you smile. You wanna dream...and even if the dream don't work out...even if it don't last...at least it felt real good tryin'.

CHELLE. I ain't said it was nothin' wrong with y'all dreamin'.

SLY. You ain't said it was nothin' right with it neither. *(beat)* It'll be somethin' Chelle. We gonna make you a believer. I been thinkin' of names to make it sound good. Sound like a place even you gonna wanna visit. Call it... Sly and Lank's Feel Good Shack. That's the one I settled on. Course, Lank probably gonna want his name first...but see, that'll just mess up the good rhythm of it. Lank and Sly's Feel Good Shack don't really make you feel that good.

(SLY moves close to CHELLE.)

First night we open, I'm gonna play a special song for you.

CHELLE. Move on from me, Sylvester.

SLY. What's your favorite? Miracles? Temps? 'Cuz mine... it's the Four Tops.

CHELLE. I don't care what your favorite is.

SLY. You say you don't...but I think you lyin'.

(SLY touches CHELLE on the arm.)

CHELLE. How many times I got to tell you to get on?

SLY. Tell me you didn't like my slow dance.

CHELLE. Sylvester, I ain't in the mood.

SLY. Tell me you didn't like for just one minute...my arms holding you tight...

(CHELLE shakes her head no. SYLVESTER moves closer to her...pulls slowly and carefully on her arm. She moves toward him in spite of herself.)

SLY. Lemme hold you, Chelle.

CHELLE. Go'on now, Sly.

SLY. I like it when you call me Sylvester. Can't nobody say my name like you. *(mocks her)* "Go'on Sylvester" "Don't slam my doors, Sylvester" "Don't touch me Sylvester".

(CHELLE laughs faintly, in spite of herself.)

CHELLE. I don't sound like that.

SLY. "Don't feel so good, Sylvester"

CHELLE. I don't say that!

SLY. "Don't be so handsome, Sylvester"

CHELLE. Now you just talkin' crazy.

SLY. "Don't love me Sylvester"…

(beat)

CHELLE. I don't…I don't say that.

SLY. You know my favorite Four Tops song?

(CHELLE shakes her head no. SLY grabs her into a slow dance.)

(SLY. sings the first six lines of "Reach Out I'll Be There" by Four Tops badly but sincerely.)

SLY.

NOW IF YOU FEEL THAT YOU CAN'T GO ON
BECAUSE ALL OF YOUR HOPE IS GONE
AND YOUR LIFE IS FILLED WITH MUCH CONFUSION
UNTIL HAPPINESS IS JUST AN ILLUSION
AND YOUR WORLD IS CRUMBLING DOWN, DARLIN
REACH OUT…COME ON GIRL, REACH ON OUT FOR ME….

(CHELLE stops dancing and looks at SLY.)

SLY. I sound good to you, baby?

(beat)

CHELLE. Yeah Sylvester. You sound real good…

(CHELLE smiles. SLY smiles back and holds her. They slow dance in silence for a moment.)

SLY. We can be somethin', Chelle. You an' me. I can make you feel like things is alright, even when they ain't. And you can do that for me. We can be that to each other.

(CHELLE pulls away.)

CHELLE. I got to finish cleanin' up, Sylvester.

(LANK comes into the basement with haste.)

LANK. Sly?! There you are. We got to go'on over to Sheps now.

SLY. It's almost four? *(checks his watch)* Oh yeah…yeah, I'm ready.

*(**CHELLE** cleans and tries to mask her worry. **SLY** notices **LANK**'s urgency.)*

SLY. What's the word?

LANK. Some boys in blue… Peanut say they been nosin' 'round over there. Askin' folks our whereabouts.

SLY. What they nosin' 'round for? Place is ours, fair and square.

LANK. Don't know but we got to go see. Somethin' givin' me a funny feelin' about it.

SLY. What kinda funny feelin'?

LANK. Think we better get over to our spot.

CHELLE. Lank…Sylvester…please…don't get into nothin' this time. Please…

LANK. We be fine Chelle. Gonna get our papers and we be fine.

SLY. That's right, sweet Chelle. Don't worry your pretty face, baby. You just save Sylvester a dance for later. Reach on out for me, and I'll be there…

*(**LANK** and **SLY** head up the steps. **SLY** looks back at **CHELLE**.)*

Four Tops. You an' me?

CHELLE. Fine, Sylvester.

*(**LANK** and **SLY** disappear. **CHELLE** sweeps and sweeps and sweeps…)*

(the sound of a tank rolling by)

(She stops sweeping. Looks at the basement door.)

(a moment of worry)

(lights fade)

Scene Four

(Lights up on **CHELLE** *and* **BUNNY**. *Two half-empty glasses of wine sit before them. The occasional sound of tanks in the background.)*

BUNNY. Summer's usually my favorite time in Detroit. July's been the best. Got my first kiss in July over on Belle Isle. Right by the beach – me and Greg whats-his-name. He was fifteen and I was only twelve. We met at the family reunion. Hadn't never seen him before but me and all the other cousins thought he was all kinds of fine. Had peach fuzz and everything. Shit drove me crazy. So while everybody else was building sandcastles and buryin' each other alive...we stole away behind the rec building and that's when we went for it. Kissin' like crazy. Let him put his tongue in and everything. Tasted like salt water. But it was alright. Sweet but a little nasty. Just how I like it. Even let him touch me on my butt and hold it real tight. *(beat)* Hope he wasn't a cousin.

*(***CHELLE*** *laughs.* **BUNNY** *does too.)*

After the reunion was over...I didn't see him no more. Didn't come back to Detroit the next time the reunion was here. All I got left to 'member him by is that salt water taste I get in my mouth when I think of July in Detroit. (beat) Wonder what my July memories are gonna be like now...

CHELLE. July's always been a time for barbeque and streamers. Daddy used to always let Lank light some kinda firecracker in the yard. Sound like somebody shootin' at us. Used to hate the sound. *(beat)* Now I miss it. *(beat)* Before Willie died, we used to take Julius and go'on down to the park and watch the fireworks off the river. I like that much better than the firecrackers in the yard. Felt more put together. Gave us something to do as a family. Grab the bucket of chicken and blankets, find us a spot on the lawn, and

stay for the whole day 'til the show started at night.
That used to be my favorite family time. Me and my
fellas. Nothin' was better.

BUNNY. You always got your fellas.

CHELLE. I guess.

(CAROLINE enters the basement.)

CAROLINE. Oh...hey there, ladies. Sorry to interrupt.

BUNNY. Just biding our time 'til Lank and Sly get back
here.

CAROLINE. Just came to ask what you'd like me to do with
the clothes you loaned me. They're all washed and
folded upstairs.

CHELLE. Your train leave soon?

CAROLINE. *(nods)* Before dawn

CHELLE. That's good. You can keep that blouse and those
shorts if you wanna. Don't hardly fit me no more
anyway.

CAROLINE. Sure okay, thanks.

*(CHELLE reaches in her bosom and pulls out some bills.
Approaches CAROLINE.)*

CHELLE. Here's a little something extra. Give you some
cushion. Pin it somewhere mysterious.

CAROLINE. Appreciate it. *(shift)* Is Lank around?

(CHELLE looks at CAROLINE and raises a brow.)

CHELLE. No. He's gone.

CAROLINE. I'll...stay awhile. Don't have to be at the station
'til an hour before.

CHELLE. May be out for a bit.

BUNNY. Way them cops over there nosin' around, could
take more than a bit.

CAROLINE. Cops? You mean...to calm the riot?

BUNNY. Sound like they doin' more than that. Few of 'em
snoopin' round Lank and Sly's bar.

CAROLINE. Few of 'em? For what?

BUNNY. Who knows? Cops is cops.

CAROLINE. Oh God…

> (CAROLINE *stares at* CHELLE *and* BUNNY… *considers…then:*)

You've got to stop him.

CHELLE. Stop who from what?

CAROLINE. You've got to reach Lank. Tell him to stay away from there.

CHELLE. What are you talking about?

CAROLINE. The cops…I tried to tell him they're dangerous –

CHELLE. What are you tellin' me girl? You got police after my brother?

CAROLINE. No! I tried to warn him to be careful. There are important officers trying to keep me quiet –

CHELLE. Keep you quiet? They the ones did that number on you?

CAROLINE. They don't want me around. Not with everything I've seen –

CHELLE. And they messin' with Lank? Do they know you staying around these parts?

CAROLINE. I don't know for sure, but if Lank gets mixed up –

BUNNY. Lord, Chelle! Them cops been talkin' to Stubby!

CHELLE. You got these bad men after my brother?

CAROLINE. I'm trying to get out of here before things get worse. I tried to tell Lank –

CHELLE. You ain't tried hard enough! Been so busy cuddlin' under him you ain't worry 'bout nothin' else.

CAROLINE. Cuddling under him?

BUNNY. Chelle, it's okay.

CHELLE. Naw – it ain't okay! Ever since this girl been here it ain't been okay! I knew she was keepin' somethin'!

CAROLINE. Listen, Michelle, I'm not trying to cause you any trouble –

CHELLE. All you been this whole time is a bunch of trouble! If you in bad with the cops, then we in bad with the

cops. It's that simple. Messed up in something and now you puttin' it on my brother.

CAROLINE. I'm not putting anything on your brother!

CHELLE. Like hell, you ain't. You think I don't see it?

CAROLINE. See what?

CHELLE. The way you slide under Lank's nose like a perfume. Tease him with your scent so you can play him for the fool. Make him believe you an' him is the same. But you ain't the same.

CAROLINE. You don't know what you're talking about.

CHELLE. I know exactly what I'm talking about.

CAROLINE. I'm sorry that being here has caused you trouble. Believe me. But that's not my intention. Lank sees that.

CHELLE. Lank got a lotta blind spots. I got 20/20. I know what it mean to have somebody like you get into his skin. He start believing things in this world is different than they really are. He start believing it's possible to be you. To live like you. To dream like you. And it ain't.

CAROLINE. How do you know it's not possible?

CHELLE. Because I do! I been living like this a lot longer than you have. Just 'cuz you hanging 'round over here don't mean you know what it's like to be us.

CAROLINE. I never said I did. But I know what it's like to be me! To never have a family or a place to call home. You have that, at least. You have something here...with each other. Something I never had with anyone...until Lank –

CHELLE. You ain't got that with Lank.

CAROLINE. You don't know what I have with him.

CHELLE. Oh, I know. You and him can pretend to be cut from the same cloth all you want. But outside this basement tell a different story. Lank got his eye on the sky but Detroit ain't in the sky. It's right here on the ground. A ground with a lot of dividing lines. We on one side and you on the other.

CAROLINE. And what about when the lines are blurred? When you feel something that can't be cut up or divided? When you know you belong somewhere even if people tell you you're not allowed? That's where we meet, Lank and me. Somewhere outside of all the zones and restrictions. Some place where we're not stuck. Maybe that's a place you refuse to go, but that's where someone like Lank and someone like me are exactly the same. And if you don't want to see that, maybe *you're* the one with the blind spot!

CHELLE. I'm the one with the blind spot? *(beat)* You can run out of here right now. Leave town with these cops chasing you. They can harass you and bruise you and even try to kill you. That may make you the same. But if you survive it, you can leave. You can disappear and reappear wherever else you want, in any zone you choose. Live a new life without permission or boundaries or some kinda limits to your skin. Can Lank do that? Can any of us? Everywhere we go, the lines is real clear. Ain't nothin' blurred about it. You might dream the same. You might even feel the same heartbreak. But 'til *he* have the same *title* to this world that you got, you and him ain't gon' never be the same! And that ain't blindness tell me that. That's 20/20.

(loaded beat)

(finally BUNNY attempts…)

BUNNY. The train station got seats… A waiting area… Even got a TV down there … Some pop machines … You be real comfortable…

(silence)

CAROLINE. Sounds like it'll be a fine place to wait.

(Beat. CAROLINE heads to the stairs.)

(She stops. Her heart in her throat.)

CAROLINE. Please at least…tell Lank for me. Just tell him…

(BUNNY nods.)

(**CAROLINE** *heads up the stairs and out the door. Sound
of tanks accompanies her exit.*)

(*beat*)

(**BUNNY** *goes to* **CHELLE** *and touches her softly on the
arm.*)

CHELLE. Whose fault is it, Bunny?

BUNNY. Whose fault is what?

CHELLE. This gap I feel in my heart? Is it Caroline's? Or
Lank's? Or Willie's? Or Sly's? Or Mama and Daddy?
Whose fault?

BUNNY. I don't know, honey. Maybe none of 'em. Maybe
all of 'em. What's it matter?

CHELLE. I don't hate her.

BUNNY. I know.

CHELLE. Can't say I love her none either.

BUNNY. I know that too.

CHELLE. Sometimes I just see the way my brother lookin' at
her…and it makes me mad.

BUNNY. I know. (*beat*) Thought it would make me mad
too…but…it don't really…

CHELLE. Why don't it? He take to her a certain way. Look
at her like she's somethin' special. More special than
anything he's ever known. And it makes me mad,
Bunny. Makes me mad he don't look at you that way…

BUNNY. Me? I don't take Lank no kinda serious. Why you
fussin' over me?

CHELLE. 'Cuz you and me…we close to the same. And I
wanna know why he don't see that somethin' special in
us? In what we come from and all we been given? I see
him lookin' at her, and it makes me feel like we ain't
enough. Like he sees somethin' better in her than he
sees in us. Throw us out like a scratched record. But
ain't we got no value?

BUNNY. Course. A lil' scratch give you character.

CHELLE. Lank don't see it like that.

BUNNY. Well…maybe he don't have to. *(beat)* Way I see it, I'm always gonna be Bunny. Had a fast tail since salt water Julys in Detroit. And Lank…he slow. He like to play fast, but he ain't fast enough for me. I'm like lightnin'…and he's like…some kinda quiet creek. I love him, I do. Love him like I love a creek on a hot day. Any water will do… *(beat)* Now if Lank get that, he alright by me. But maybe he never get that and he still alright by me…'cuz I'm always gonna be Bunny, regardless. And you always gon' be Chelle. You got to let Lank be Lank…whatever that is…it's alright… whatever you are…that's alright, too…

(CHELLE smiles and touches BUNNY's hand on her shoulder.)

(The basement door opens.)

(LANK comes in wildly disoriented. Blood on his shirt. He stumbles down the stairs.)

CHELLE. Lank! Jesus – what happened to you?

BUNNY. Baby – what'd they do?

LANK. He's…he's…they…

(CHELLE rushes over to LANK and tries to help him to the couch.)

CHELLE. Come down here – you been / hurt?!

LANK. No!

(He holds her off –)

BUNNY. Lank!

CHELLE. What happened to you? / You bleedin'!

BUNNY. Somebody hurt you, baby?

LANK. They um…they…

(long pause)

CHELLE. They what? What'd they do?!

BUNNY. What happened honey? Jus take it / slow

CHELLE. They hurt you???

LANK. *(carefully)* They come up on us – the pigs –

CHELLE. Come up on / you how?

BUNNY. Honey you scarin'/ me.

LANK. – come to burn us out/ but we got 'em – motherfuckers…

CHELLE. They burn the / bar?!?!

BUNNY. Where's Sly Lank?

(sound of tanks rolls by)

LANK. He…

(long pause)

CHELLE. Lank you really scarin' me. What happened.

(pause)

LANK. Tanks come 'round the corner–

CHELLE. What /tanks?

BUNNY. What'd they do?!

LANK. Those goddamn tanks…goddamnit Sly!

CHELLE. Where's Sly Lank?

LANK. I told him…I told him stop runnin' – I told him

CHELLE. What do you – **BUNNY.** No–
 What are you–????

LANK. I told him…

CHELLE. Where's Sly, Lank?

BUNNY. Chelle–

CHELLE. What'd they do?!?! Where is he???

BUNNY. Chelle.

LANK. He's…they…

(long pause)

*(***CHELLE*** *looks at* ***LANK*** *in horror.)*

CHELLE. No.

LANK. He's…dead.

CHELLE. No!

BUNNY. *(breathless)* Oh God…

LANK. They…

CHELLE. No!!!!

LANK. They killed him.

BUNNY. No.

LANK. They killed / him!!!

CHELLE. Stop it! Stop it!!! Don't say that!!

(*CHELLE collapses and wails.*)

(*LANK stumbles and clings to anything. The couch. The crates. The chair. The rail. The floor. Whatever will hold him.*)

(*He finally releases. A wail. A scream.*)

LANK. They killed SLY!!!!!!!!!!!!!!!!!!!!!!!!!

(*blackout*)

Scene Five

(CHELLE sits by the record player alone. No music. She sips coffee delicately. A wind could knock her over.)

(LANK comes through the basement door. He is cleaned up. Fresh shirt. He comes down and watches his sister for a moment.)

(silence)

(LANK goes over to the bar. Pours a drink to the brim.)

(Holds his glass up to the sky. Pours a little back into the sink in reverie.)

(beat)

(LANK sips.)

(CHELLE remains stoic.)

CHELLE. Julius call this mornin'.

LANK. That right?

CHELLE. Say he heard the U.S. Army was up here now and they been quellin' this fire. He sayin' he want to come back home to check on us.

LANK. You tell him we fine. Just stay at that school where he safe from all this.

CHELLE. I told him to stay put. I told him we...fine...

LANK. You tell him 'bout...

CHELLE. No...not now...not like this...

(beat)

LANK. Caroline ain't come back?

CHELLE. She...gone. Said to tell you goodbye...

LANK. Well I guess that's it. You wanted her gone so she gone.

CHELLE. It wasn't safe, Lank.

LANK. I know, Chelle. *(beat)* I know you...you see her and you see me and you ain't like it. And I don't know

what to say 'bout it. When I talked to her I just felt like all the rules put on me 'cuz of this or that or where I'm from or what I am…it was possible to break 'em all and still have somethin'… *(pause)* But I guess that wasn't real. The rules is the rules, and soon as you step outside the space you been given, it don't do nothin' you think it's gonna do. You thinkin' it's gonna open the world up. All it do is upset the world and set it on fire. All it do is make you lose your best buddy.

CHELLE. Lank…

*(**LANK** holds in a wail.)*

LANK. I lost him, Chelle.

(beat)

I was there with him, 'til the end. There when we signed the papers in our name. There when he went runnin' after them pigs who showed up tryin' to burn us down. Tryin' to send us a message for bein' uppity. There when we chased after 'em. There when them big tanks rolled 'round the corner. He ain't seein' what I see. Told him stop. Don't run after. He ain't see 'em rollin' up. Them soldiers that come to back up the police for the riots. Saw niggers chasin' after cops and decided the niggers were the ones to shoot. And I was there when they shot him, Chelle. There when he fell. Went back to him and lifted him in my arms. Felt his blood soak my shirt. Saw his chest open –

CHELLE. Don't, Lank.

LANK. I was there, Chelle. 'Til the end. *(beat)* He was my best buddy.

CHELLE. I know, Lank.

LANK. And he's gone.

(beat)

I messed up, Chelle. Was tryin' to really be somethin'… but it's just like you say…nothin' but foolish…

CHELLE. *(softly)* Since when you listen to anything I say?

*(CHELLE falls silent. She moves over to the 8-track
player. Picks up cassettes.)*

CHELLE. How you play this thing?

LANK. Want me to show you?

*(He starts to approach her. She holds out her hand to
stop him.)*

CHELLE. No I…wanna do it myself. Just…tell me…

LANK. Turn the cartridge face up. Have the closed part
facing you. Leave the open side to the machine. And
push it in.

(CHELLE does so.)

CHELLE. Then what?

LANK. You turn on the power.

(She scowls at LANK. Pause.)

CHELLE. I figure that much.

LANK. Well…why ain't you doin' it then?

CHELLE. When I'm ready.

LANK. Ready for what?

CHELLE. Just when I'm ready.

(beat)

You gonna put this 8-track player in that bar of ours?

(LANK looks at CHELLE in surprise.)

LANK. Ours?

CHELLE. It'd be nice for us to have some music. Some way
for people to dance and feel good.

*(LANK is somewhat breathless. He tries to question her,
but the words fail him. She answers the gesture:)*

Lank…it don't always make sense to me how you walk
through life. Don't match how I see the world and
know to get through it. But I suppose it don't have to.
You start somethin', you got to finish it. Nothin' wrong
with dreamin', Lank. (beat) It's still standin' ain't it?

LANK. Yeah…

CHELLE. Well then…Don't be talkin' like it's some kinda ashes. Hear me?

LANK. Yeah… *(more solidly)* Yeah… *(pause)* Lank and Sly's Feel Good Shack… I'm'a tell all the folks that come up in there how it came to be. How Sly was the mastermind. How we stood our ground through the fire, even if the rest of Detroit is nothin' but dust. We got somethin' we started and we gonna finish it. That's what I'm'a tell folks.

CHELLE. *(softly)* Good…

*(**LANK** grabs a hat and heads for the stairs.)*

LANK. I got to go get the truck. Get his sister. Take her to see his… *(beat)* Be back this evenin'.

CHELLE. Alright.

*(**LANK** heads up the stairs.)*

CHELLE. You tell them folks…when they ask. You tell 'em Sylvester wasn't no looter. Tell them he was a businessman. A dreamer. That's what he was…what you both are…

LANK. I will…

CHELLE. And you…call the place Sly and Lank's, will you? Lank and Sly's Feel Good Shack just don't make you feel as good…

*(**LANK** stares at **CHELLE**. A moment. A smile? A tear? Something in between…)*

LANK. Sly and Lank's Feel Good Shack…yeah… *(solidly)* Yeah…

*(**LANK** disappears behind the door.)*

*(**CHELLE** sits for a moment. Stands. Goes to the bar. Pours herself a drink. Sips.)*

(Goes to 8-track player. Turns on the power.)

*(The Four Tops, "**REACH OUT, I'LL BE THERE**".)*

*(**CHELLE** sways her hips slowly.)*

(She moves over to the pole. Grabs a pillow. Something to indicate companionship.)

(She begins to sing along through her tears… the first six lines of "Reach Out I'll Be There" by Four Tops.)

CHELLE.

NOW IF YOU FEEL THAT YOU CAN'T GO ON
BECAUSE ALL OF YOUR HOPE IS GONE
AND YOUR LIFE IS FILLED WITH MUCH CONFUSION
UNTIL HAPPINESS IS JUST AN ILLUSION
AND YOUR WORLD IS CRUMBLING DOWN, DARLIN
REACH OUT…COME ON GIRL, REACH ON OUT FOR ME….

*(**CHELLE** reaches out her arms.)*

(She dances freely…lovingly…even nastily… But definitely free.)

*(Lights fade on **CHELLE**.)*

End of Play